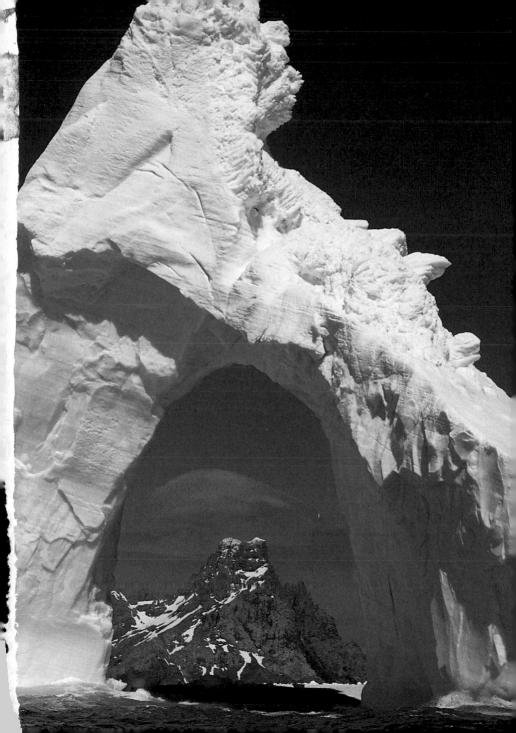

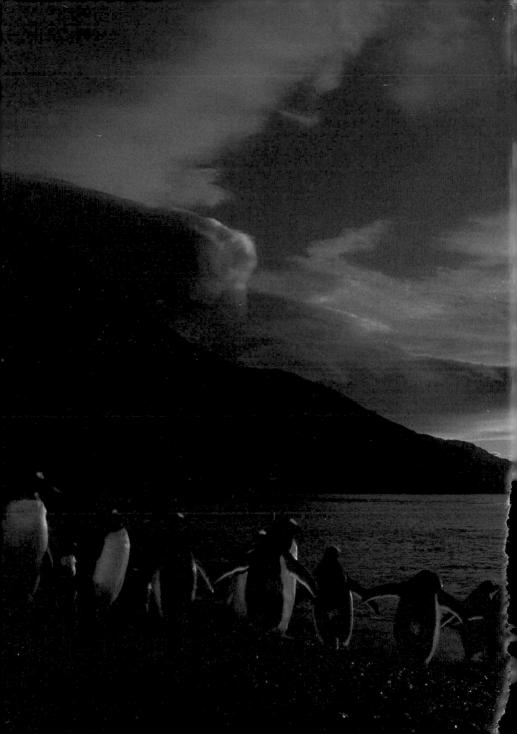

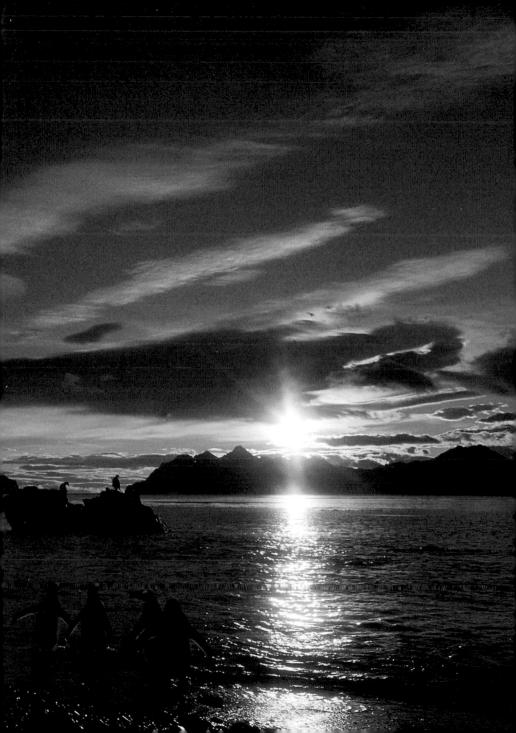

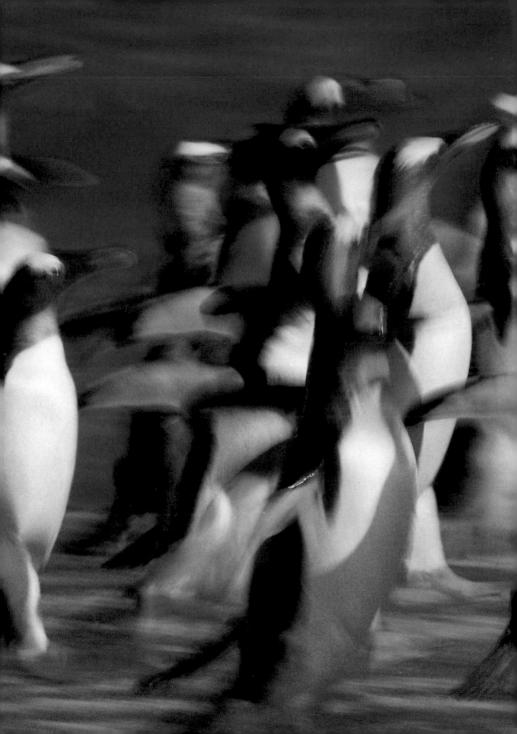

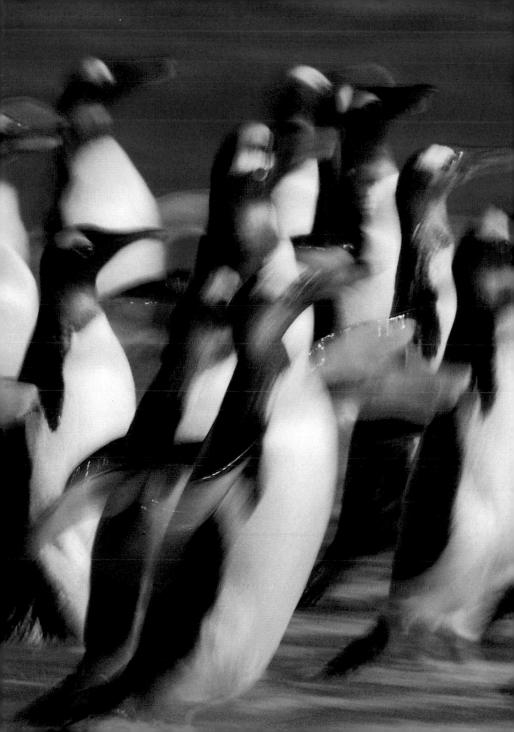

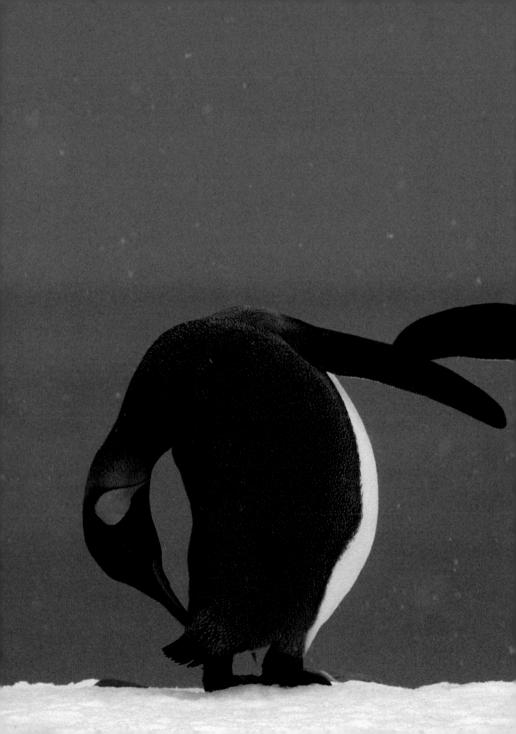

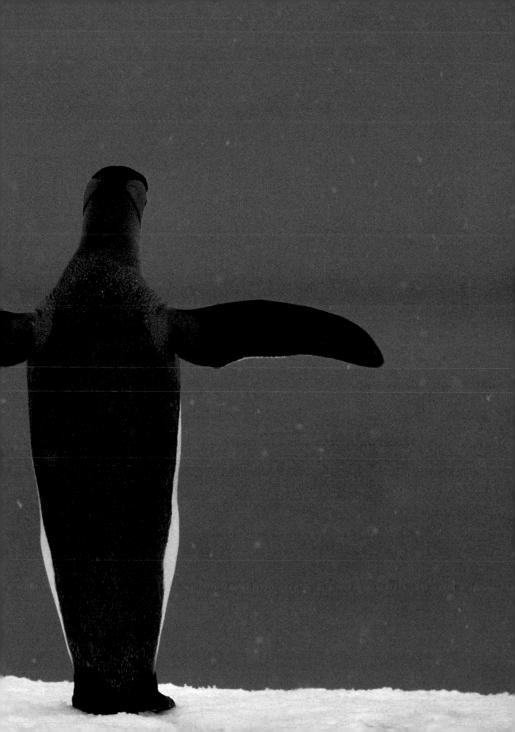

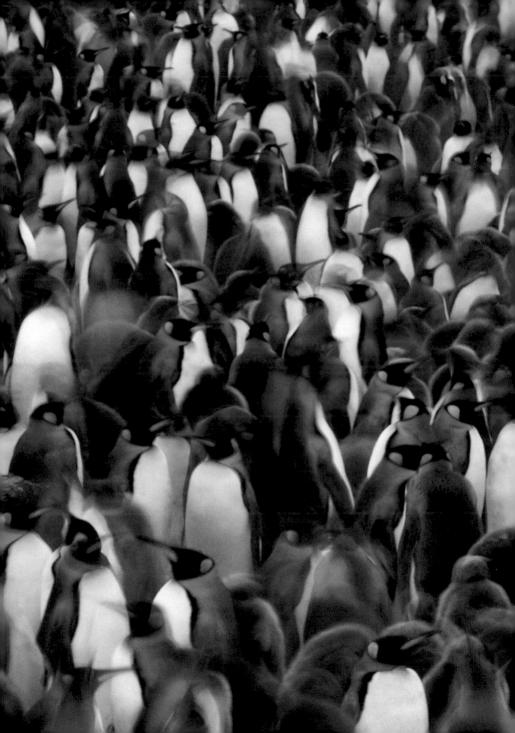

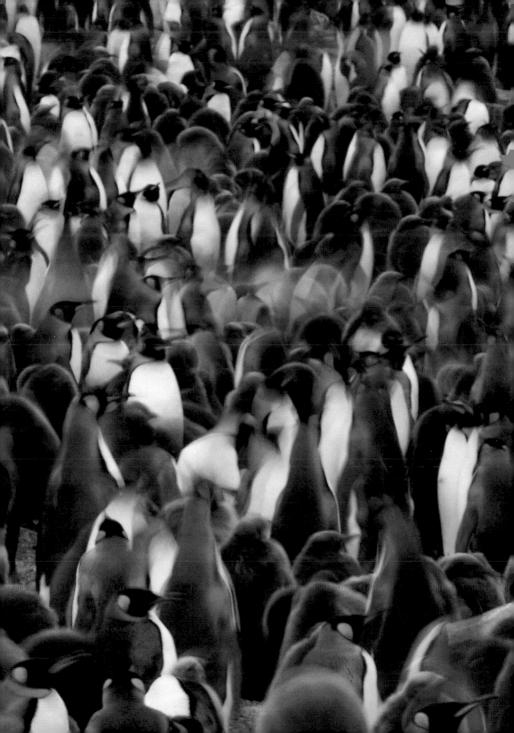

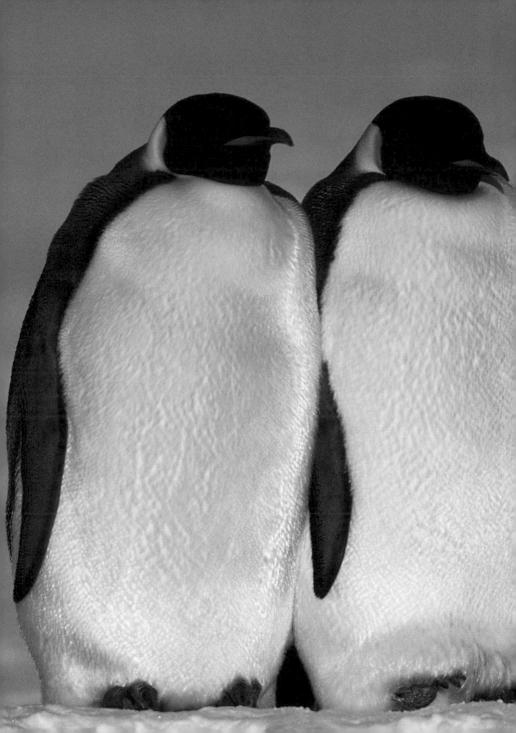

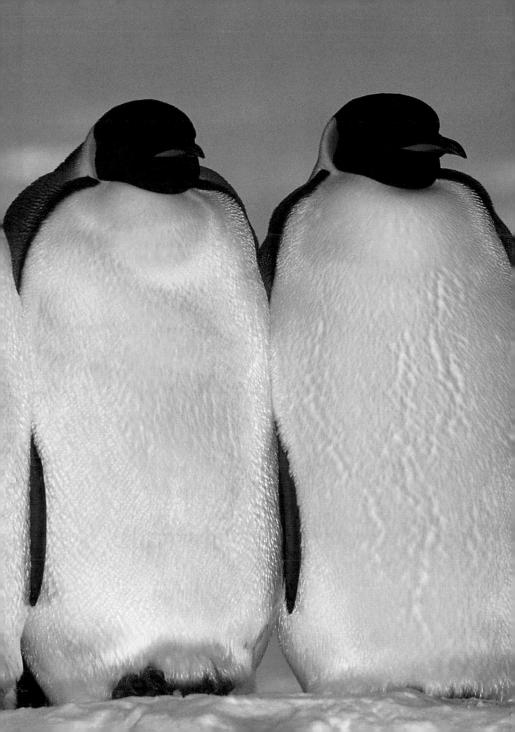

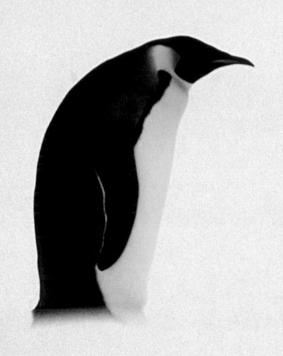

PENGUIN FRANS LANTING

EDITED BY CHRISTINE ECKSTROM

TASCHEN

KÖLN LONDON LOS ANGELES MADRID PARIS TOKYO

FOR CHRIS

Produced by Terra Editions in association with TASCHEN GmbH

Original edition: © 1999 Terra Editions, Santa Cruz, California Pocket edition © 2003 Terra Editions, Santa Cruz, California www.lanting.com

> Published by TASCHEN GmbH Hohenzollernring 53, D-50672 Köln, Germany www.taschen.com

Photographs and text copyright © 1999 Frans Lanting

Editor: Christine Eckstrom, Santa Cruz, California Design: Jennifer Barry Design, Sausalito, California

Cover: Emperor penguin family, Antarctica
Page 1: Iceberg, South Georgia
Pages 2–3: Gentoo penguins, South Georgia
Pages 4–5: Gentoo penguins, Falklands
Pages 6–7: King penguins, South Georgia
Pages 8–9: King penguin colony, South Georgia
Pages 10–11: Emperor penguins, Antarctica
Pages 12–13: Emperor penguin, Antarctica

All rights reserved.

No part of this book may be reproduced in any form or by any electronic or mechanical means, including information storage and retrieval systems, without prior written permission from the publisher or the producer, except by a reviewer who may quote brief passages in a review.

Library of Congress Control Number: 2002116496

Printed in Italy ISBN 3-8228-2415-1

INTRODUCTION 16

COMING TO LAND 20

GOING TO SEA 66

LIVING ON ICE 110

PHOTOGRAPHING PENGUINS 158

IMAGE INDEX 162

ACKNOWLEDGMENTS 186

INTRODUCTION

The first penguin I ever saw was in the tropics. It looked out of place, yet it belonged on the black volcanic shores of the Galápagos Islands, where cold sea currents touch the sun-scorched land. Penguins live here because of the Humboldt Current, which brings water rich in marine life from the Antarctic to the Equator. But even so, life in the tropics is a marginal existence at best for a penguin. No wonder the Galápagos penguin I watched splashing around in the shallows is the rarest of the 17 species of penguins recognized by scientists.

Penguins come in sizes ranging from the diminutive fairy penguin to the four-foot-tall emperor, and they are divided into four main clans. The Galápagos penguin belongs to a group known as jackass penguins. Most of them live along the coasts of South America and southern Africa, and they all bray like donkeys.

Also recognized are six species of crested penguins – feisty birds with red eyes and

vellow head ornaments shaped like whiskers and tassels. The widespread rockhopper is circumpolar, while its cousin, the macaroni, is only found on a few subantarctic islands. Other relatives live south of Australia and New Zealand. The clan of brush-tailed penguins includes the most numerous species. the chinstrap, along with Adélies and gentoos. These are the small black-andwhite penguins of popular imagination, who are often seen on icebergs. The regal penguins include the two biggest and most striking species, kings and emperors. The emperor has the most extreme distribution of all penguins: It is the only one truly dependent on the Antarctic continent.

Penguins have feathers, lay eggs, and do everything else other birds do, except fly. They lost that ability when their ancestor, a seabird, became specialized in flying through water, using modified wings shaped like the flippers

of marine mammals. Most penguins live in the chilly seas surrounding Antarctica, where their diving ability allows them to penetrate the ocean as no other bird can. They are so successful that they breed in staggering numbers on the handful of islands that break the surface of the Southern Ocean. These are lonely isles like Bouvet, forever trapped in ice, or towering South Georgia, reputed to have the foulest weather on earth. It is hard to appreciate the isolation of these islands

until you have attempted to get there. They are in the latitudes known as the Roaring Forties, the Furious Fifties, and the Howling Sixties. Every field trip I made to see penguins turned into an expedition. My explorations occupied three summers and led me

on some of the most extreme journeys of my life.

I started my odyssey in the Falkland Islands, where people and penguins mix in an unexpected coexistence. On some islands nesting penguins share coastal pastures with grazing sheep; on others I saw penguins walk through minefields left from the war between England and Argentina. I landed by helicopter, courtesy of the RAF, on a small island where I spent most of the summer immersed in

the lives of rockhoppers and gentoos. The following year Antarctic explorers Jérôme and Sally Poncet invited me for a unique circumnavigation of South Georgia, one of the great penguin islands on the planet. We spent two months exploring the coast on their yacht,

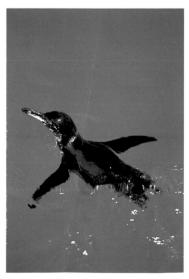

Galápagos penguin, Galápagos Islands

Damien II, and did not see another vessel until the journey ended. Along the way I went ashore to camp among great colonies of king penguins. A later journey by icebreaker allowed me to get to specks of lands even farther south, such as the South Orkney and South Sandwich Islands, where immense colonies of chinstraps and Adélies form during the brief Antarctic summer. Emperor penguins presented the ultimate logistical challenge. A Hercules cargo plane flew me from

Patagonia to the interior of Antarctica, where I transferred to a small plane on skis with a huge extra fuel tank that occupied most of the cabin. Surrounded by mounds of supplies and with pots and pans wedged between my feet, I flew across the continent to a remote

emperor colony on the frozen surface of the Weddell Sea, where I camped among the birds for a month.

As a naturalist I appreciate penguins for their remarkable life histories. Each is unique, and exquisitely timed to the hard rhythms of a polar world. Among the smaller birds there is a sense of perpetual motion that became a recurring theme in my work. As a photographer I felt challenged by the opportunities to juxtapose their individual identities with their collec-

fess I am also drawn to penguins for the same reasons most people find them irresistible.

I cannot help but anthropomorphize when I watch these birds in action, and I am not shy about investing my images of wild animals with human emotion.

tive nature. But I con-

I feel it helps to bridge the gap between their worlds and ours.

This book is a personal interpretation of the penguins I met, rather than a natural history of all penguins. I aimed to evoke personalities, from the boisterous rockhoppers to the mellow gentoos, from the stylized displays of kings to the stoic gatherings of emperors. I wanted to create an impression of who these penguins are and what they go through. I hope my work is seen as an homage to the individual within them all.

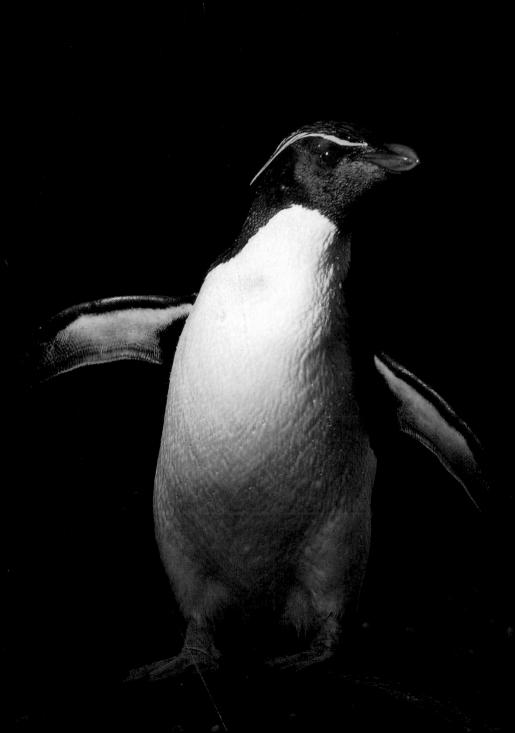

COMING TO LAND

COMING TO LAND

Big waves roll toward the windward side of New Island, a sliver of land on the western edge of the Falkland archipelago. They carry flocks of rockhopper penguins trying to get ashore. Hundreds of feet below my vantage point on a bluff, where I have to crouch down to avoid getting knocked over by the furious wind, the waves break over a ledge that has long been a favored landing site for rockhoppers. When the penguins sense the perfect wave, they ride it in like expert surfers, then disappear in a maelstrom of foam and surge. It seems a miracle that they can survive this ordeal, yet they

emerge casually and stand around, sleek and wet, before they head inland to colonies sheltered by tussock grass.

It is not difficult to figure out where they are going. Generations of rockhoppers have followed the same route up the steep slopes. Their claws have left grooves in the rocks, which are worn smooth like the stones of ancient Roman roads. There is evidence that some of these trails may have been used for thousands of years. I follow a party of penguins as they make their way along one trail. They climb the rocks in a fashion true to their name, hopping, some-

Page 20: Rockhopper penguin, Falklands Right: Landscape, Falklands

times using their beaks to push themselves up, and quarreling as they go. These are brawny birds who do not give an inch. Their colonies are a cacophony of disputes. Long before you see a rockhopper colony you hear it, a raspy ruckus of voices echoing off the rocks where thousands of penguins are gathered. At the edge of the colony the landing party disperses, and each individual finds its way to the two square feet it claims as home. There it meets up with a partner who breaks out in a frightening whine, by way of welcome. Rockhoppers affirm their pair bond by screaming and tossing their heads from side to side. I sit down in the tussock and watch the private lives of countless penguins unfolding around me.

From the windward side of New Island, I make my way over the crest through waving grass and down loose talus slopes to the sheltered leeward side, into the gullies and alleyways where

another penguin nests in darkness. It is a chunky, big-beaked character, whose calls sound like a donkey in distress.

This cousin of the more petite Galápagos penguin is known as the Magellanic, first described on Magellan's 1520 passage through the straits near Cape Horn that now bear his name. It is a furtive character that nests in underground burrows, a strategy that serves this penguin well against the predators it has to cope with on the mainland of South America, where most of them live.

Downslope from the Magellanic burrows stretch sweeping bays of white beaches and icy clear water, jade-green in the shallows, through which gentoo penguins shaped like torpedoes are racing ashore. They are running a deadly gauntlet. Sea lions lurk in the shallows along the leeward side of the island, and every day gentoos fall prey to them. The penguins know the sea lions are there, cruising just outside the surf break. Each

morning thousands of gentoos gather on the beach, scanning the sea for a sign of their enemies. They have to get past them to reach their fishing grounds offshore. The gentoos mass at the water's edge, reluctant to go in. No one wants to be first, but eventually one takes the leap, which triggers a surge of penguins into the sea. In the afternoon when the flocks return, they wheel around offshore, anxious to make the desperate dash across the last hundred yards of water. They come in, porpoising, shoot up out of the water, and throw themselves ashore feetfirst, running as soon as they touch the ground.

At the end of each summer day, lines of gentoos loaded with krill march back to their colonies, where plump chicks await their return. The chicks are listening for a parent's call, which they can distinguish from any others. On hearing the call, they rush toward it, but other chicks eager for a meal often try to

muscle in. To separate freeloaders from genuine offspring, adult gentoos set off on wild runs with hungry chicks in hot pursuit. The chicks chase food-laden parents at full speed, as the parents dodge and turn to try and shake off the imposters - until only their true chicks remain. At the edge of the colony, birds with hooked beaks watch for opportunities. They are caracaras, hawk-like birds of prey who scavenge among the penguins. For them the summer is a bonanza of eggs and chicks. But it does not last long. On the rare day when the wind is not blowing a gale, you can be lured into thinking this is an easy place to live. Wildflowers and the sounds of meadowlarks in the air enhance that feeling. But soon storms will sweep in from Cape Horn. By the time the weather turns cruel in autumn, most of the penguins have left for open water. They are seabirds, after all. Onshore not much will remain to mark their passage except a

few more scratches in the rocks, some bits of bones and eggshells, and a scattering of hungry caracaras.

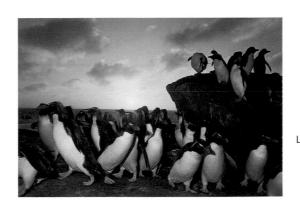

Left and following pages: Rockhopper penguins, Falklands

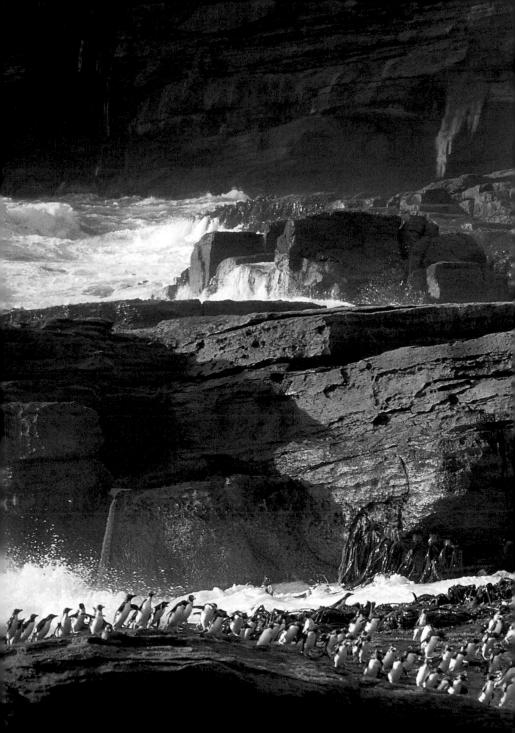

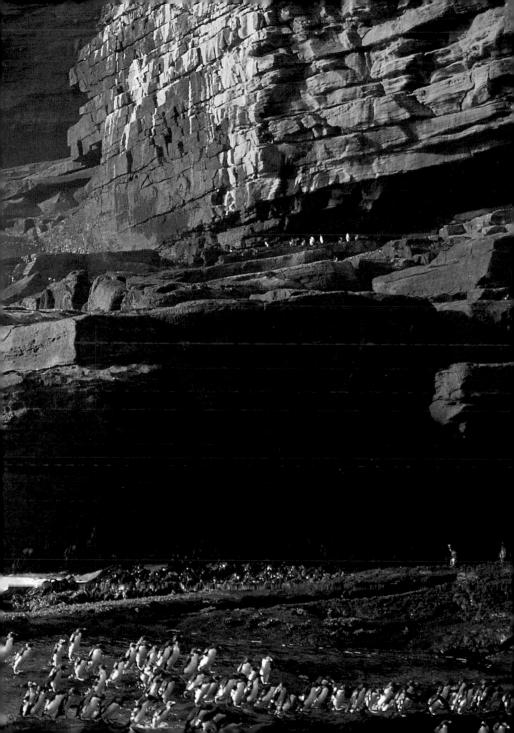

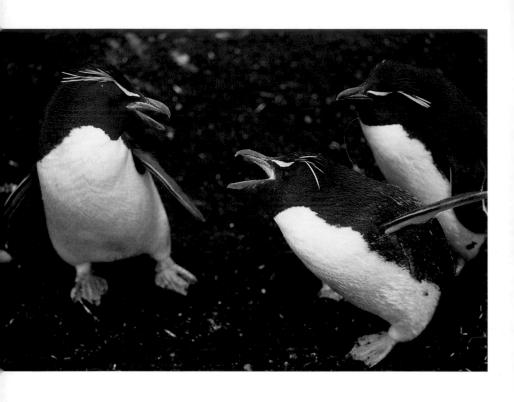

Above, right and page 31: Rockhopper penguins, Falklands Pages 32–35: Macaroni penguins, South Georgia

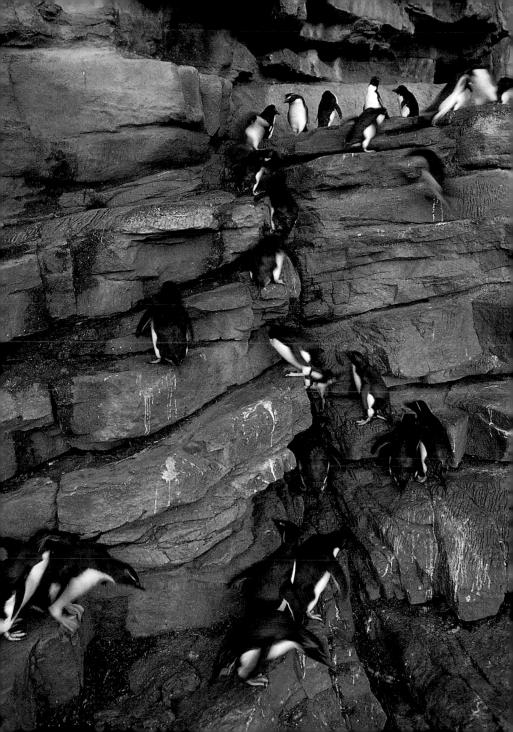

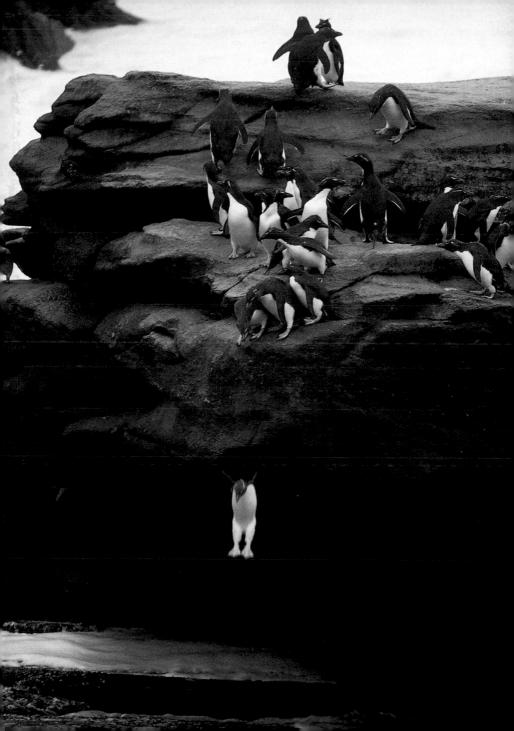

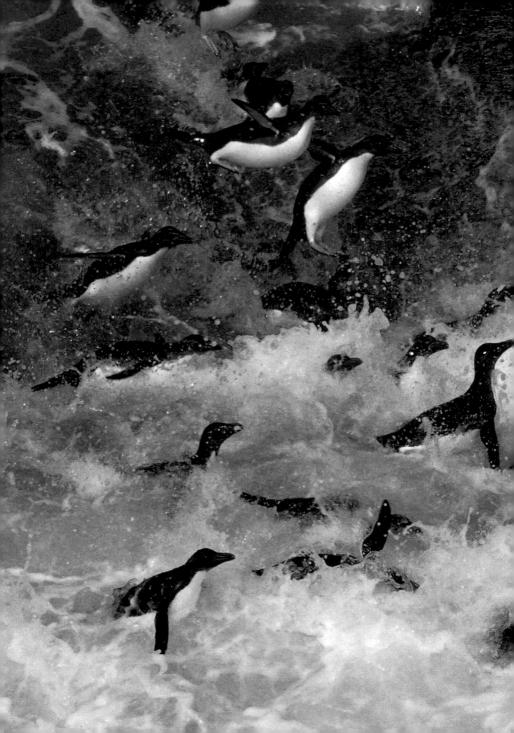

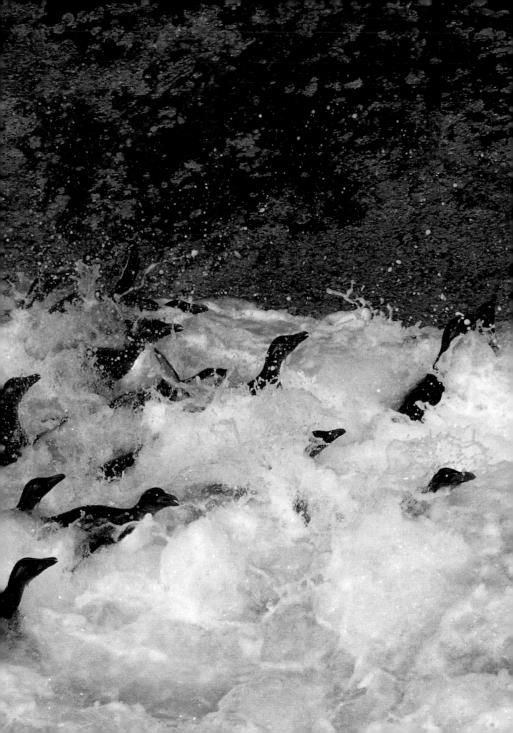

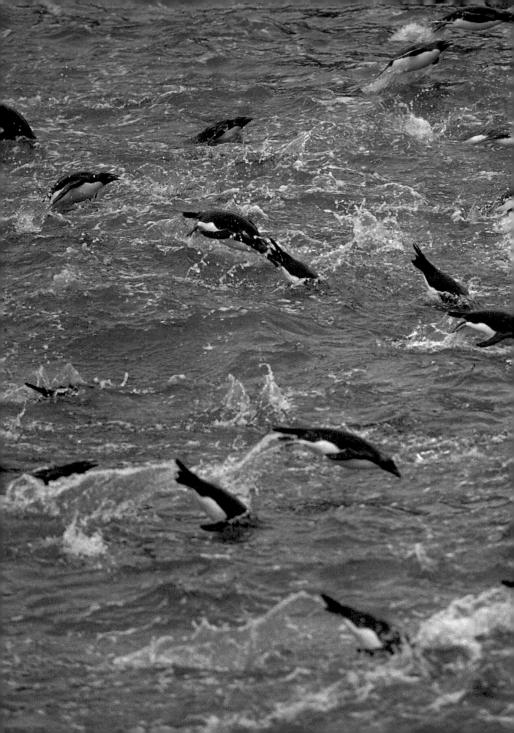

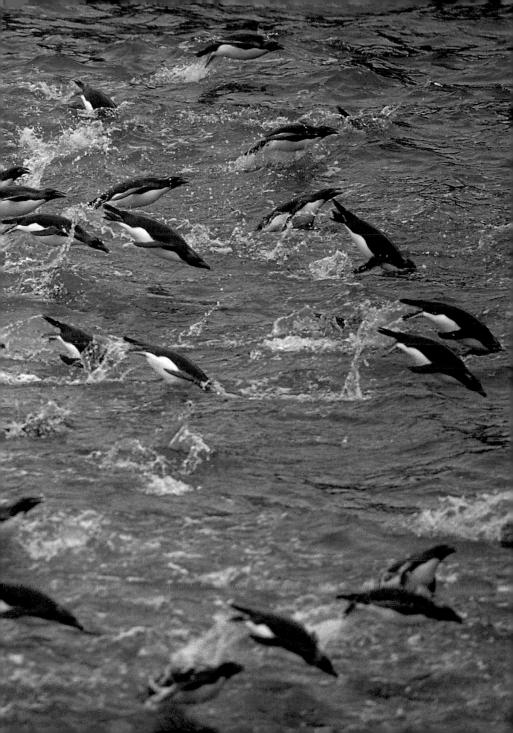

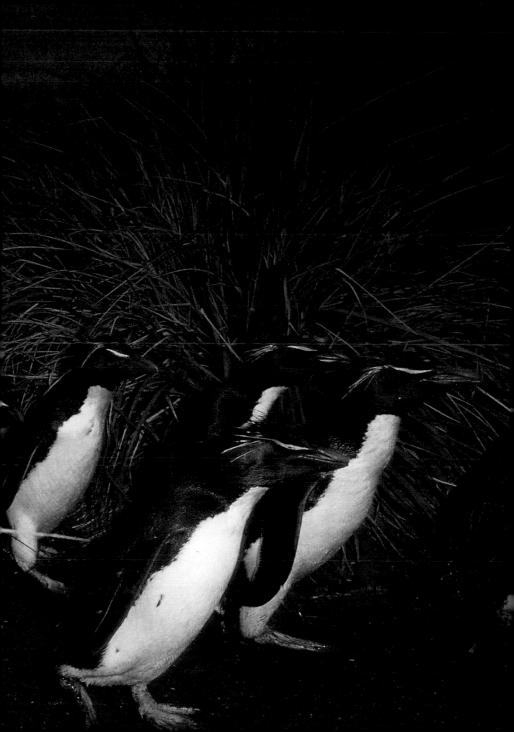

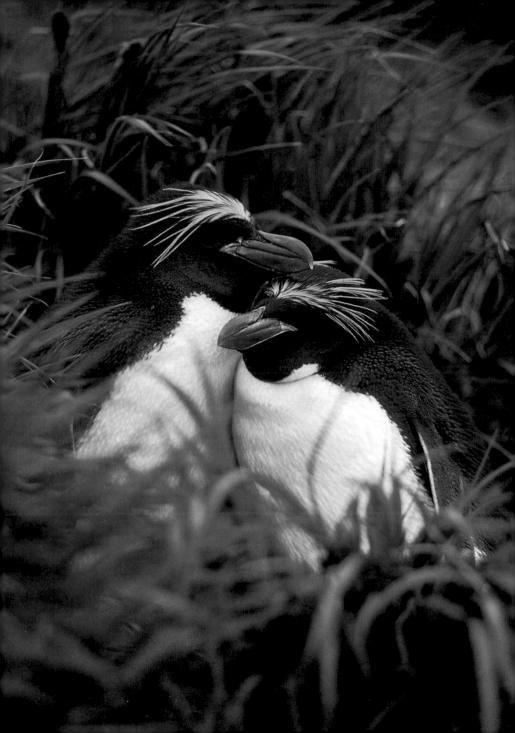

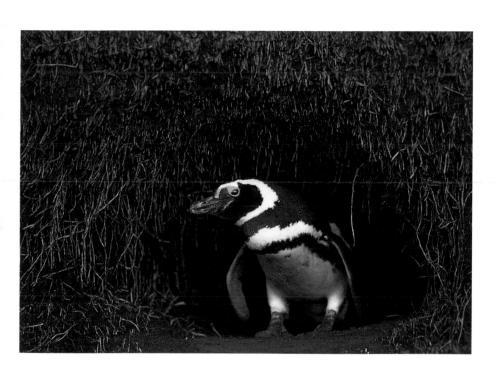

Preceding pages: Rockhopper penguins, Falklands Left: Macaroni penguins, South Georgia Above: Magellanic penguin, Falklands

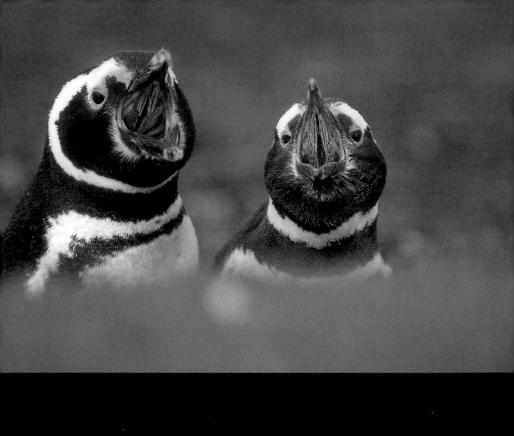

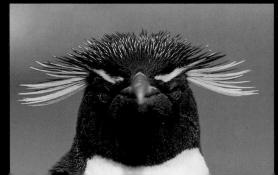

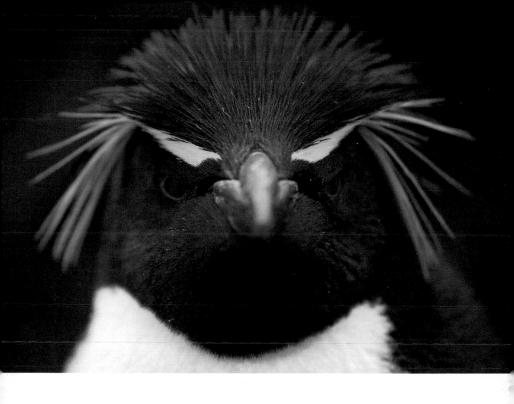

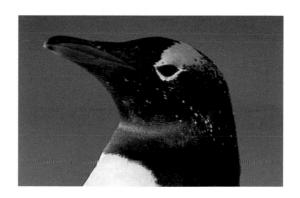

Top, left: Magellanic penguins, Falklands Left and top: Rockhopper penguin, Falklands Above: Gentoo penguin, Falklands Following pages: Striated caracaras, Falklands

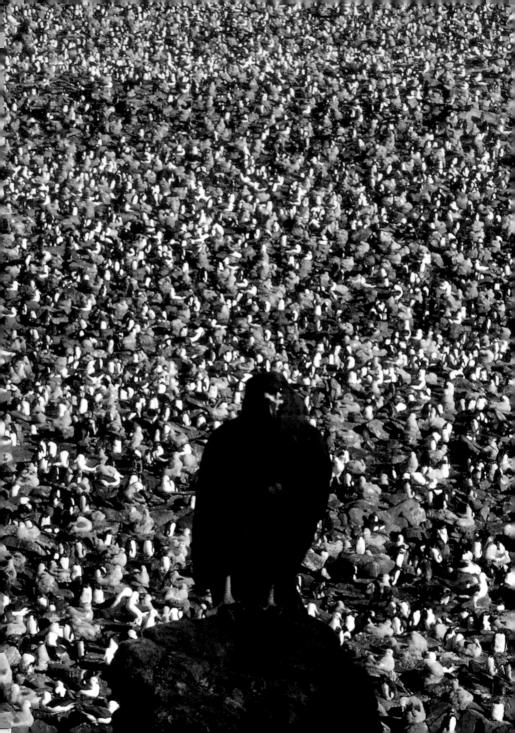

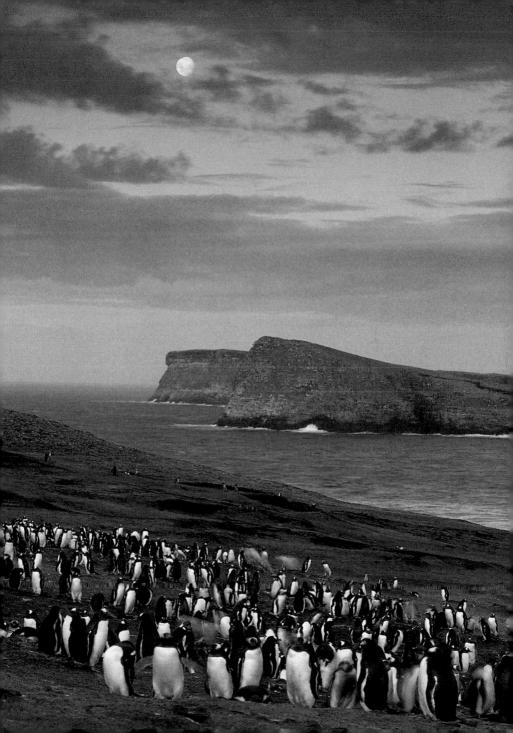

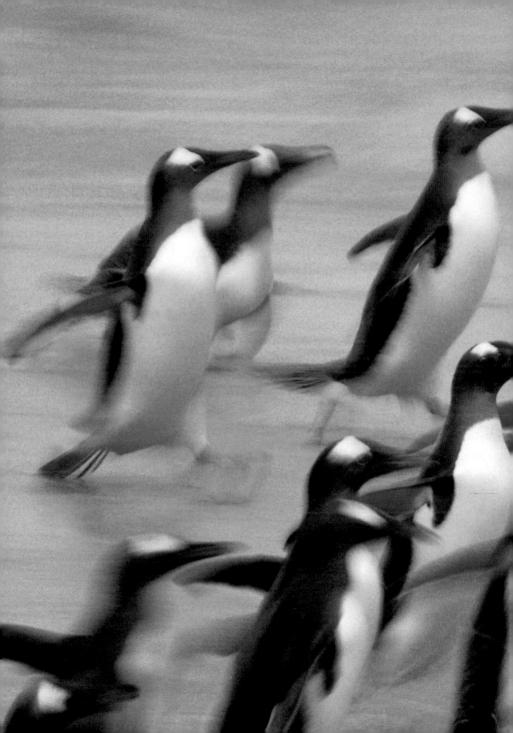

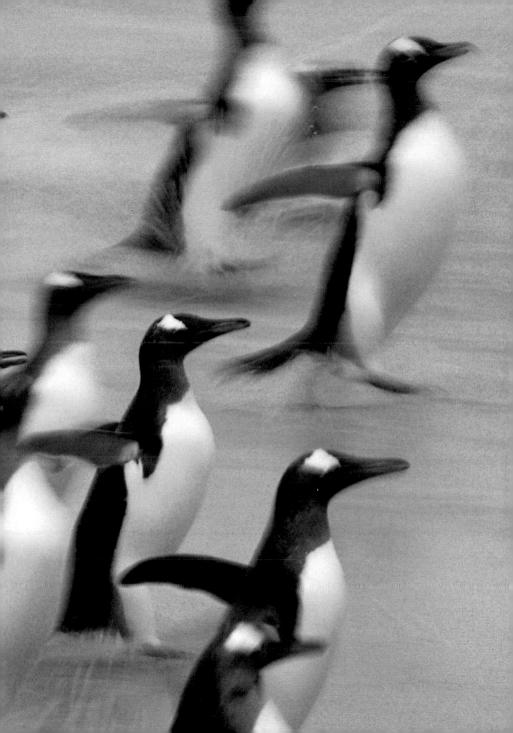

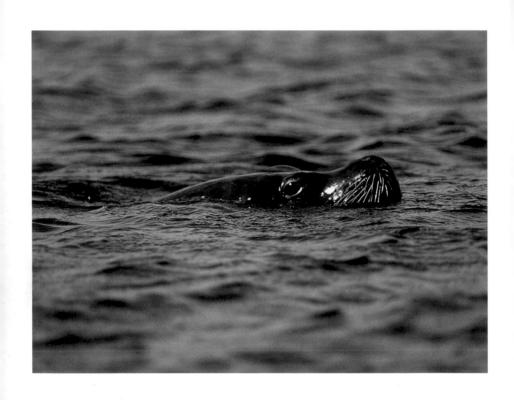

Pages 45–47: Gentoo penguins, Falklands Above: Southern sea lion, Falklands Right: Gentoo penguins, Falklands Following pages: Southern sea lion and gentoo penguins, Falklands

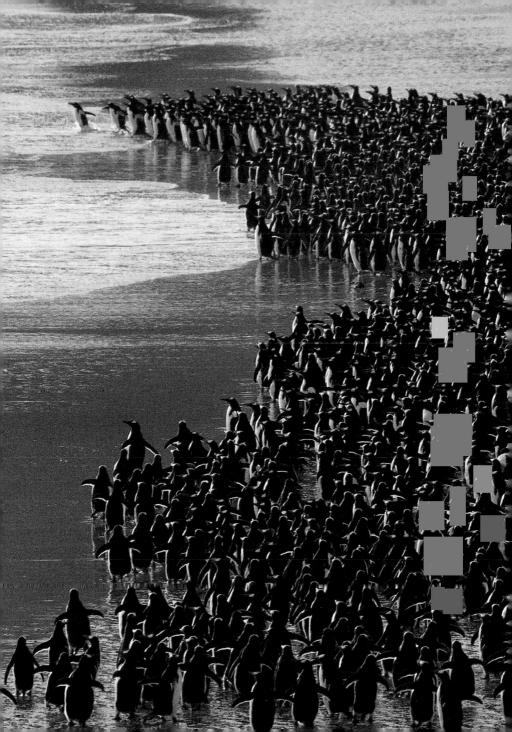

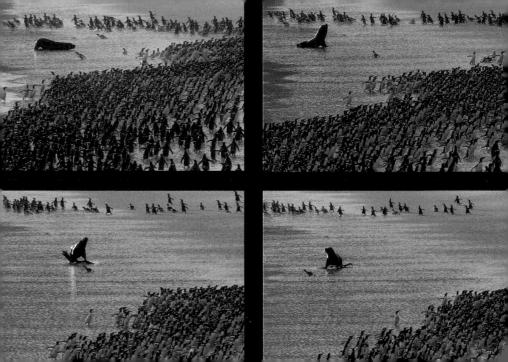

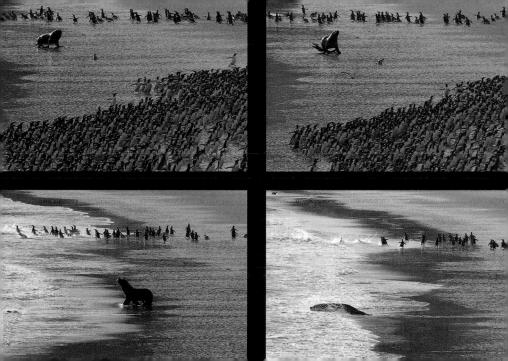

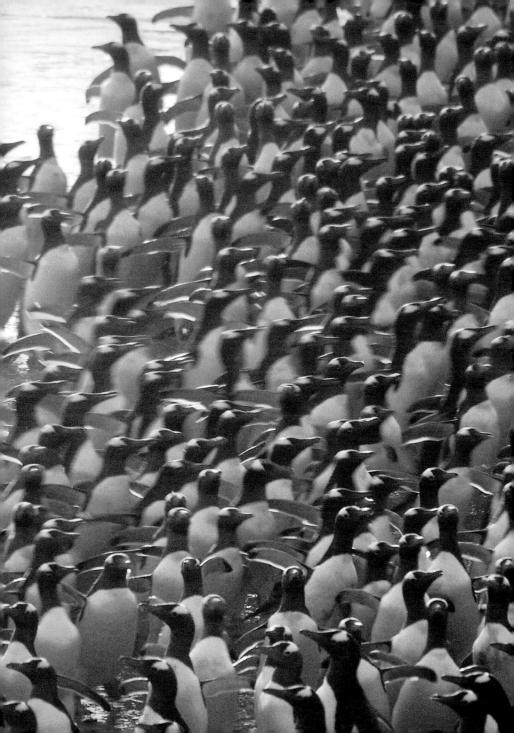

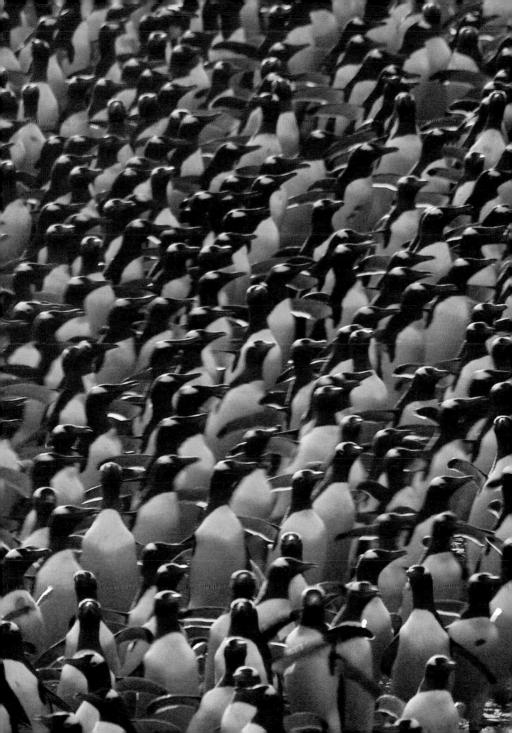

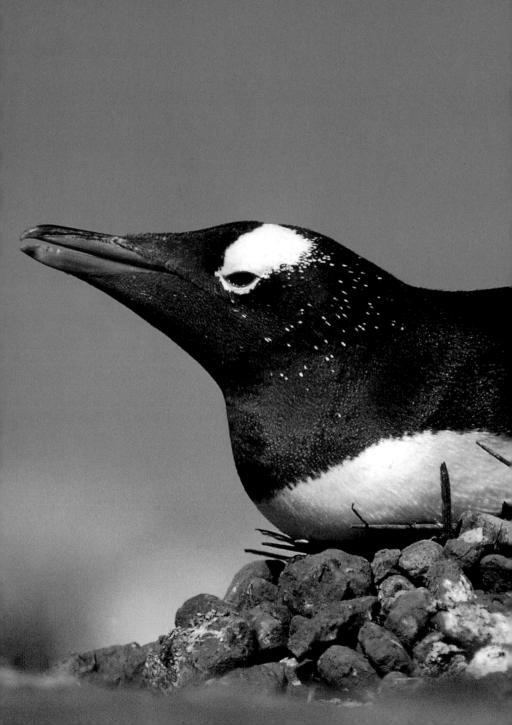

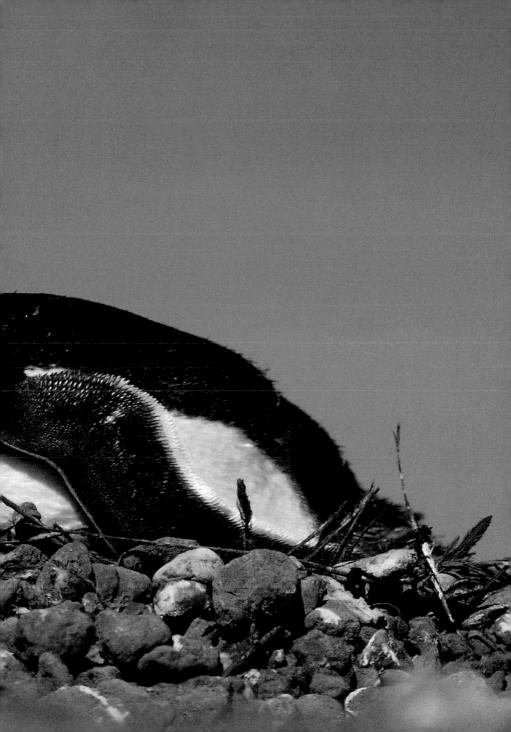

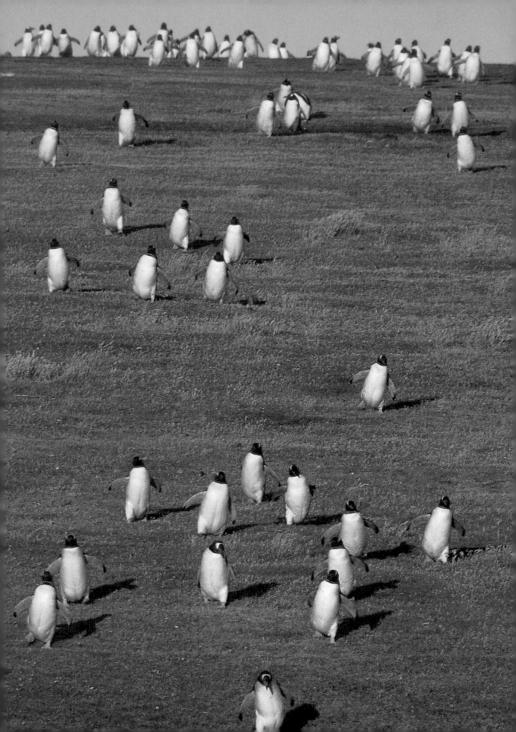

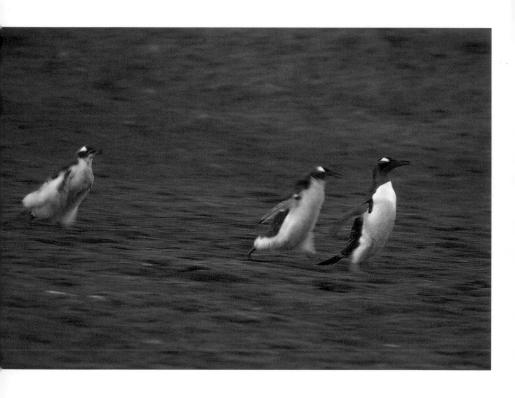

Above: Gentoo penguin and two chicks, Falklands Right: Gentoo penguin and chick, Falklands

Page 61: Gentoo penguin and chicks, South Georgia

Pages 62-65: Gentoo penguins, Falklands

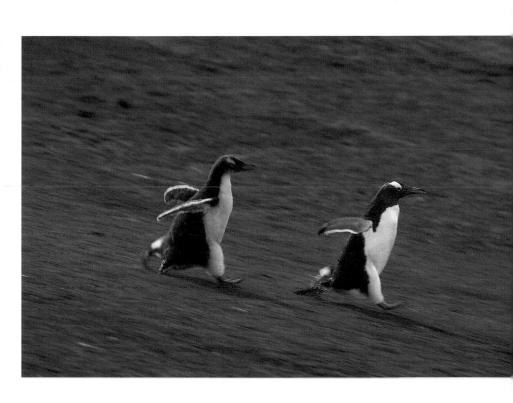

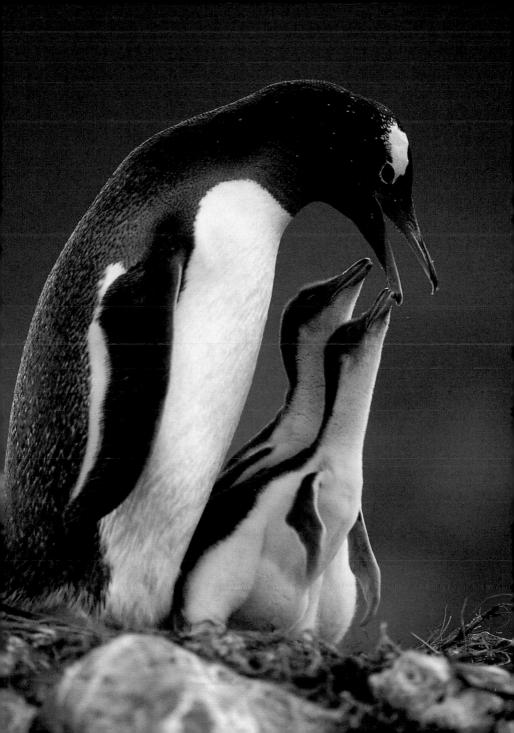

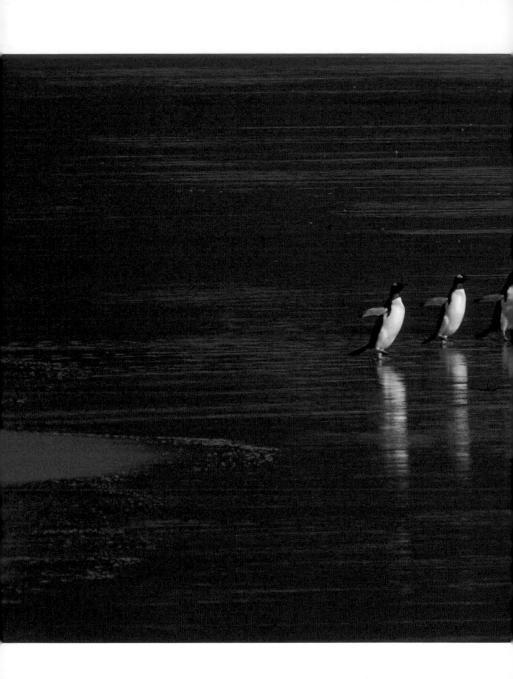

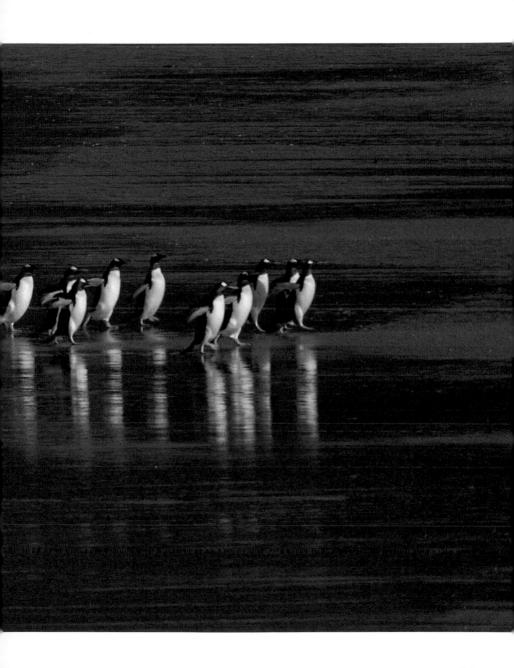

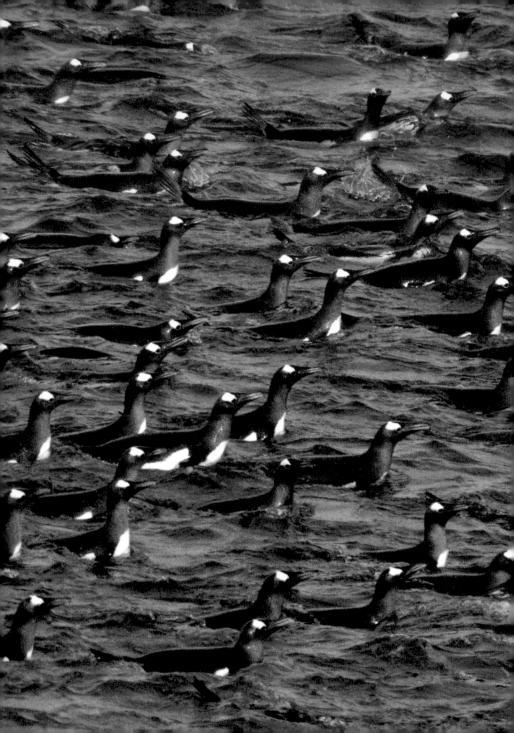

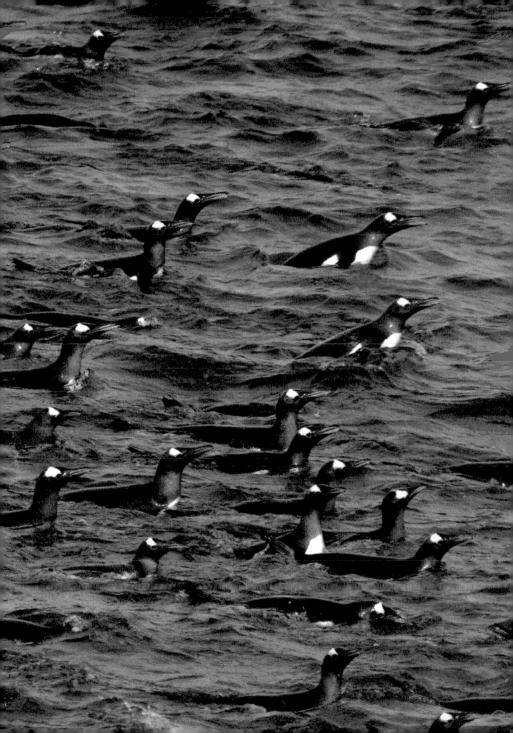

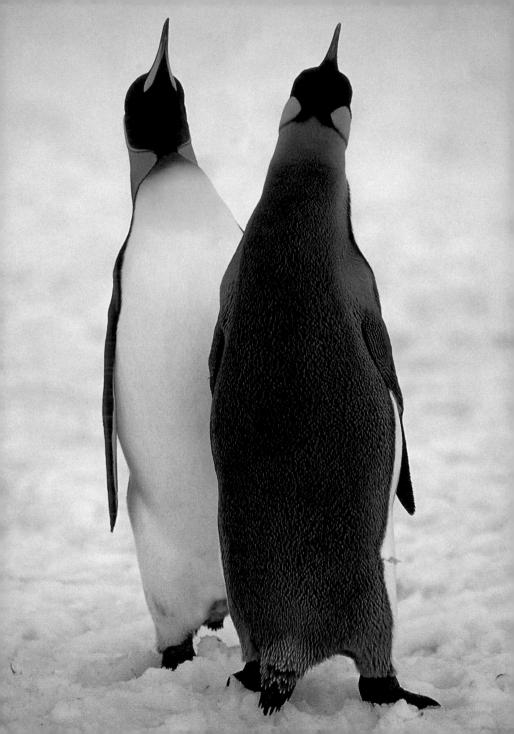

GOING TO SEA

GOING TO SEA

Suddenly the sea is boiling with birds. Penguins are everywhere. Kings surface like submarines and chinstraps porpoise in arcs through the steely gray water. I am sailing down the coast of South Georgia toward the windswept southern tip. In the days before whalers decimated their populations, spectacular congregations of great whales feasted here on krill, along with millions of penguins. The whales are gone, but the penguins remain. Their life cycles are entwined with fluctuations in the marine food chain of the Southern Ocean, which goes through a boom and bust every year. At the onset of winter the food chain collapses; but in the nearendless daylight of summer the ocean becomes a cornucopia of krill, squid, and fish-food for uncounted penguins.

In the midst of this sea of plenty rises an island described as "the Alps in midocean." Unnamed peaks and uncharted glaciers alternate along the spine of South Georgia, where mountains rise nearly 10,000 feet. Along the frigid bays and beaches, king penguins mass in colonies of tens of thousands of birds.

From a distance they look like encampments of armies. The first whalers who walked into one of these great bird cities thought that king penguin adults and their older chicks were two different species.

The large birds dressed in fluffy brown coats they named woolly penguins.

Certainly, they thought, these birds could not be related to the slender black-and-white penguins marked with vivid orange, standing guard over near-naked newborn young.

It is not surprising the whalers were confused. The reproductive cycle of king penguins is governed by an improbable rhythm. In a king colony birds appear in all stages of breeding at the same time. Some are courting; some sit on eggs. Some nurture newborns, but there are also chicks that look bigger than their parents. These are more than a year

old. King penguins have one of the longest breeding cycles of any bird. It takes them up to 16 months to raise a single chick. There is just not enough time in the short summer of the subantarctic for a king penguin to reach maturity. So parents stretch the rearing of one young over two summers. Unfortunately for the chicks, there is a winter in between, during which thousands of them stand around, starving, while their parents go far offshore to find food. In winter an adult often forages at sea for weeks before it can gather a single meal for its offspring. For months on end the chicks

are fed perhaps once every three weeks.

Many do not make it through the winter.

By spring the survivors look emaciated.

But then the food chain of the Southern

Ocean rebounds, the fishing becomes

easy, and the chicks are fed enough to

fully mature and fledge in midsummer.

As the last chicks from a previous breeding cycle still linger on the beach at the onset of summer, new partnerships are forming. On the dark beaches of St. Andrews Bay, sleekly shaped adult king penguins come ashore looking for mates. Each sports a bright, tear-shaped patch of orange on both sides of its neck. They

Page 66: King penguins, South Georgia Left: North coast, South Georgia

are of crucial importance. One researcher who painted a king penguin's orange markings black found that the bird could not attract a mate—but it succeeded as soon as rain washed off the paint. Kings show off their orange patches to each other in ceremonial displays that look like pantomime with sound effects. Two prospective partners will face each other, then alternately stretch and sag in solemn synchrony. They trumpet and point to the sky. They lead each other on silly walks. Sometimes groups of admiring females form around males with particularly impressive displays. This inevitably leads to female flipper fights. But ultimately pair bonds form, and by the time couples engage in advanced courtship, rattling their bills and dabbling like ducks, the pairs are oblivious of all but each other.

The first people to see king penguins perform their courtship on South Georgia were Captain Cook and his crew, who explored this rugged coastline in 1775.

Cook was convinced that he had found the long-sought continent of Antarctica. When he rounded South Georgia's southern tip and saw the other side of the island stretch away to the north, he felt bitterly disillusioned. The wild south coast has not changed since Cook laid eyes on it. There are few sheltered bays and coves. It is rough even for penguins. The mountains are covered in snow right down to the beaches, where gigantic icebergs are grounded. They float in from the south, calved from the ice shelves and glaciers of Antarctica.

When you cross the lonely expanse of the Southern Ocean by boat, icebergs appear like apparitions. Each has its own history, which can be interpreted from its shape and color. Some of these great castles of ice carry diminutive escorts. They are chinstrap penguins, trim-looking birds with a thin black neck band that gives them the appearance of wearing a permanent grin. Millions of these brush-

tailed penguins breed further south, at the edge of Antarctica. They exploit a fleeting opportunity. When the ice around the continent softens each summer and food sources explode in the sea, chinstraps are ready. Wasting no time on elaborate courtship or extended chick care, they race through a breeding season in little more than two months. The zone of sloshing summer ice is chinstrap habitat, and they often haul out on icebergs and floes drifting north from Antarctica, travelers from a frozen world.

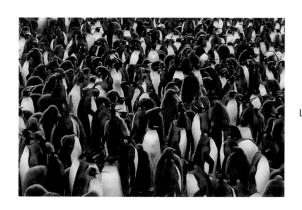

Left and following pages: King penguin colony, South Georgia Pages 74-77: King penguins, South Georgia

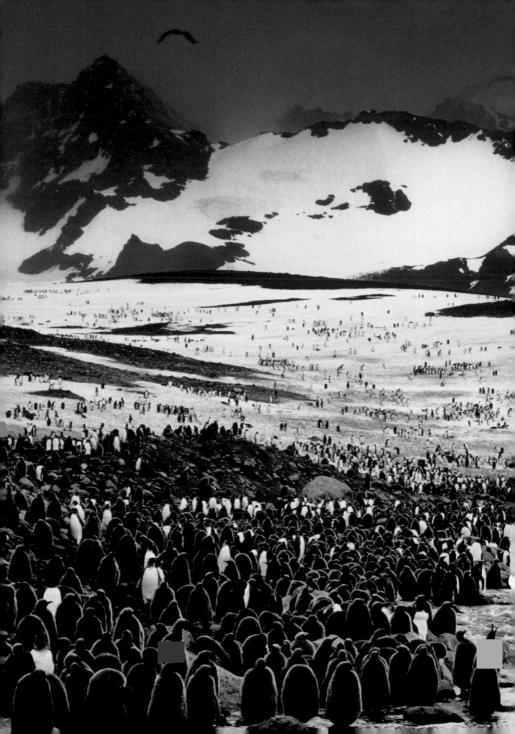

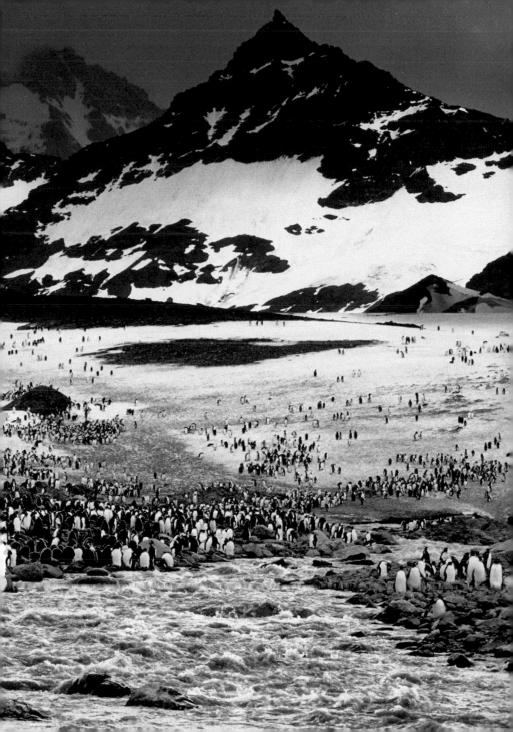

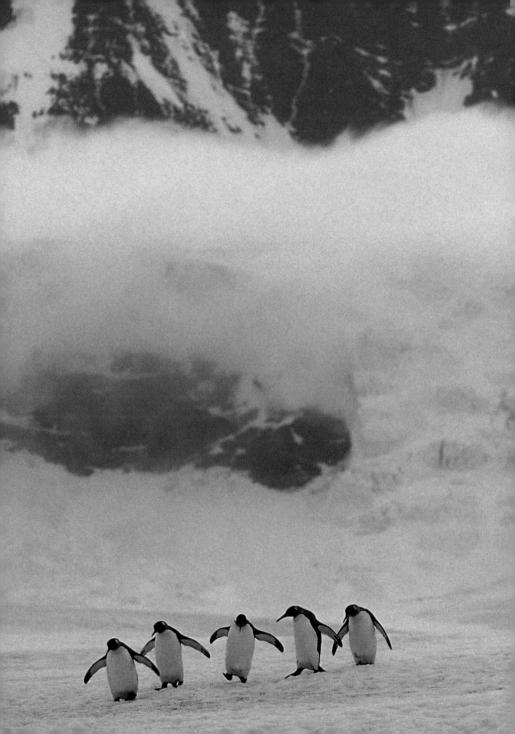

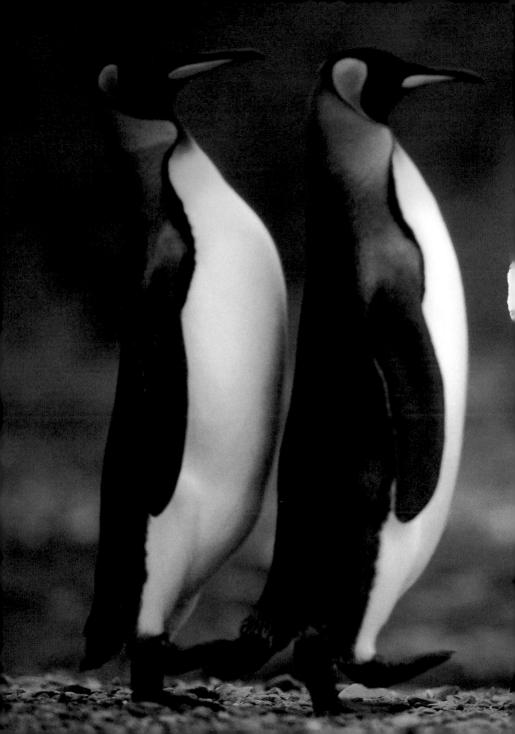

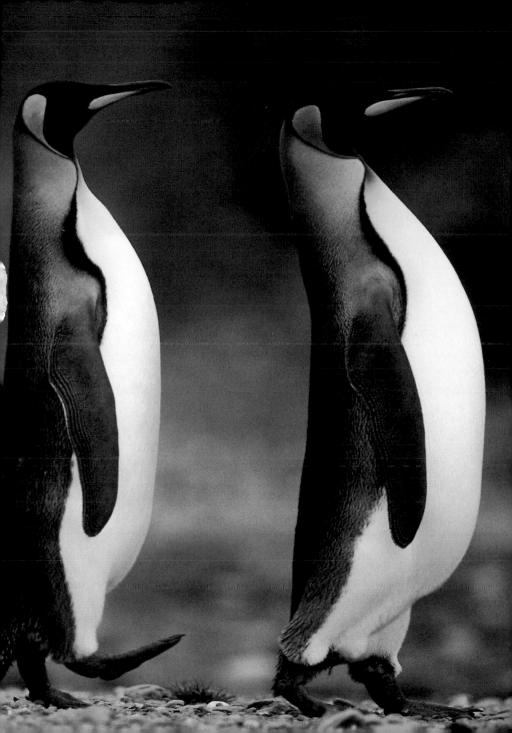

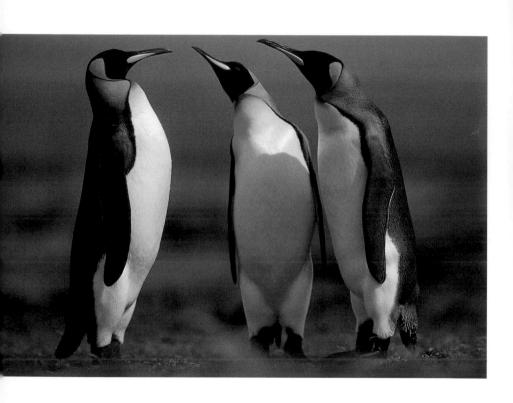

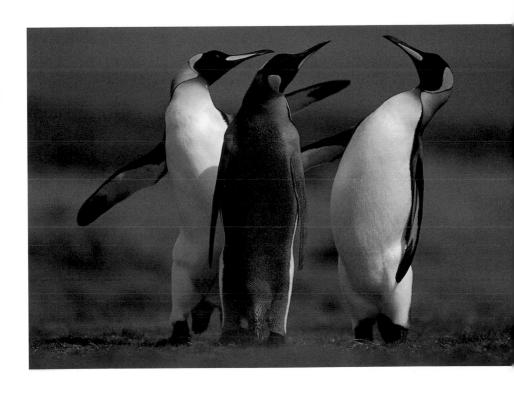

Left, above, and following pages: King penguins, South Georgia
Page 83: King penguins, South Georgia
Pages 84–85: King penguin colony, South Georgia
Pages 86–87: King penguin colony, Falklands

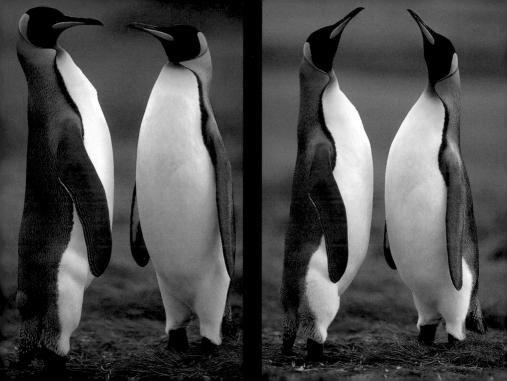

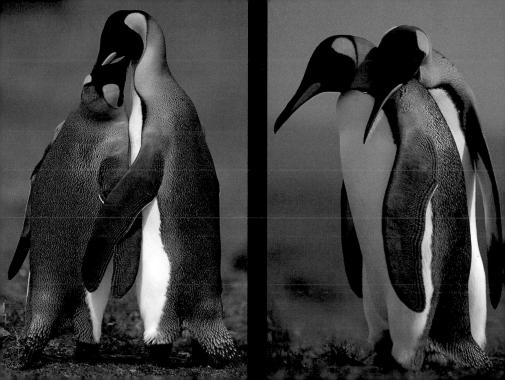

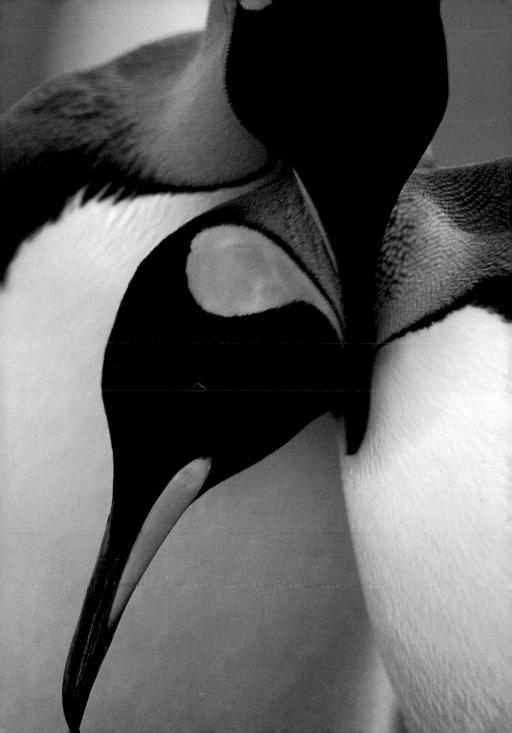

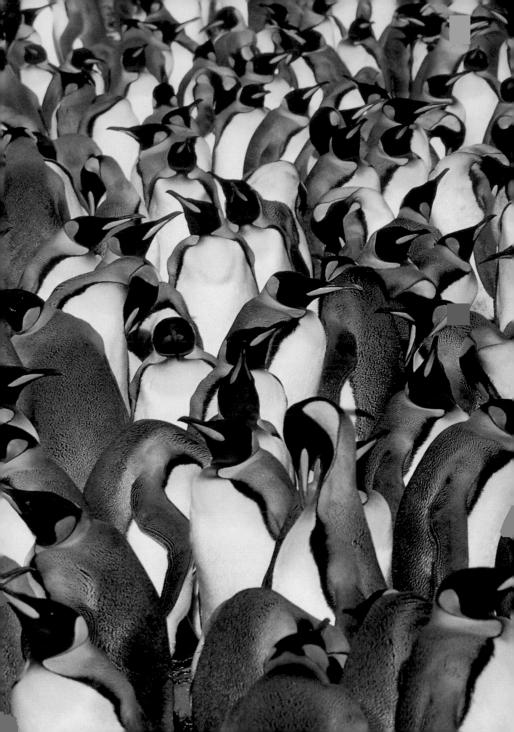

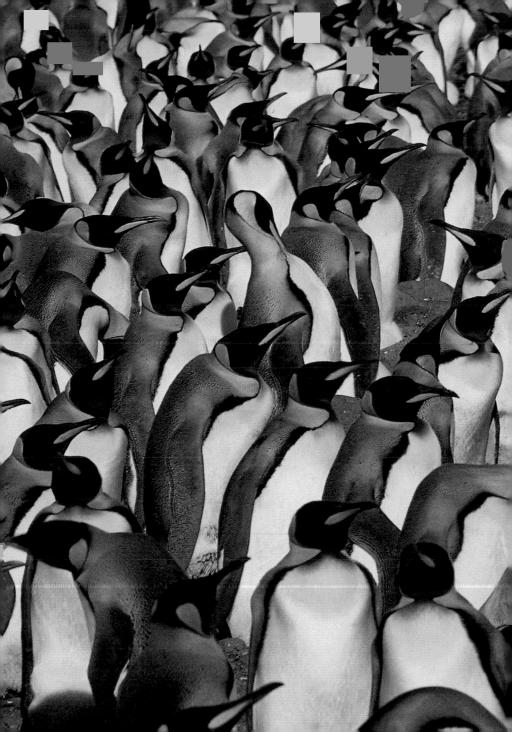

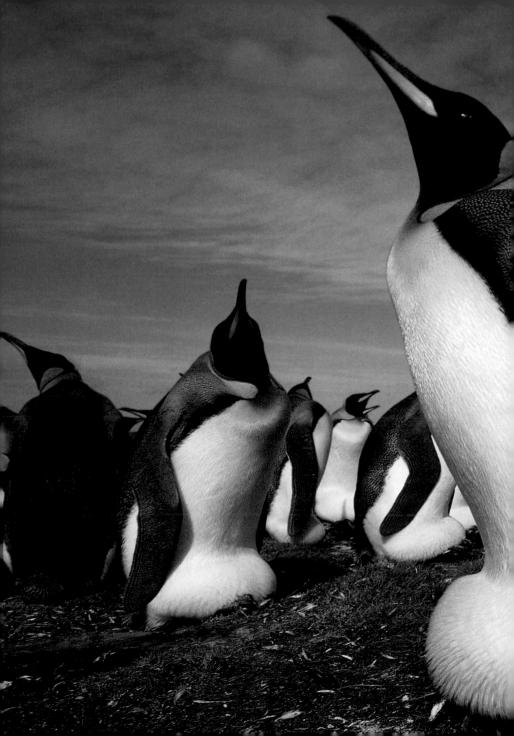

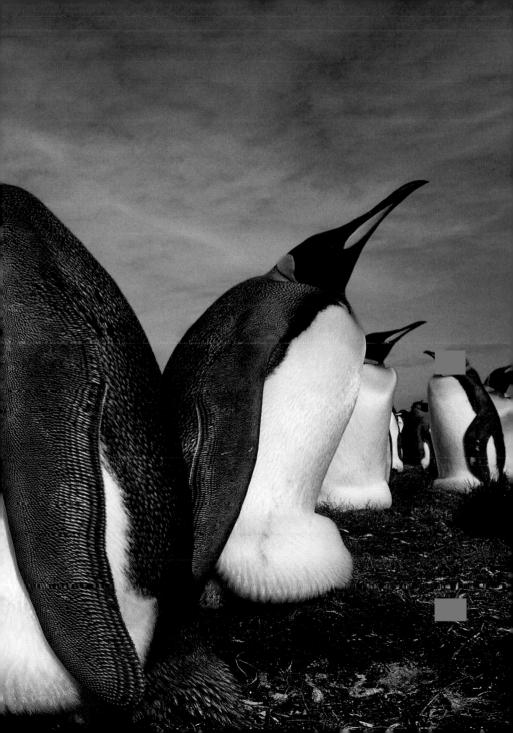

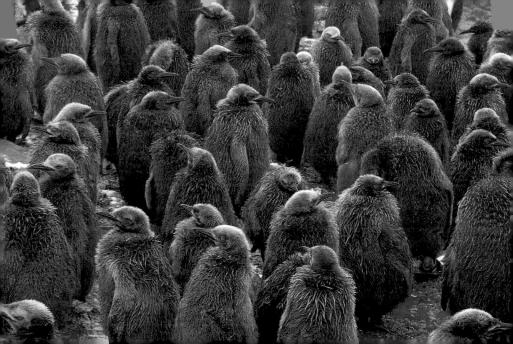

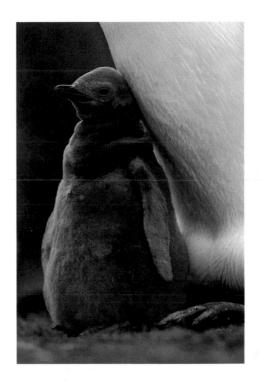

Left and above: King penguin chicks, South Georgia Pages 90–91: King penguin colony, South Georgia Page 93: King penguin chick, South Georgia Pages 94–95: King penguin feathers, South Georgia

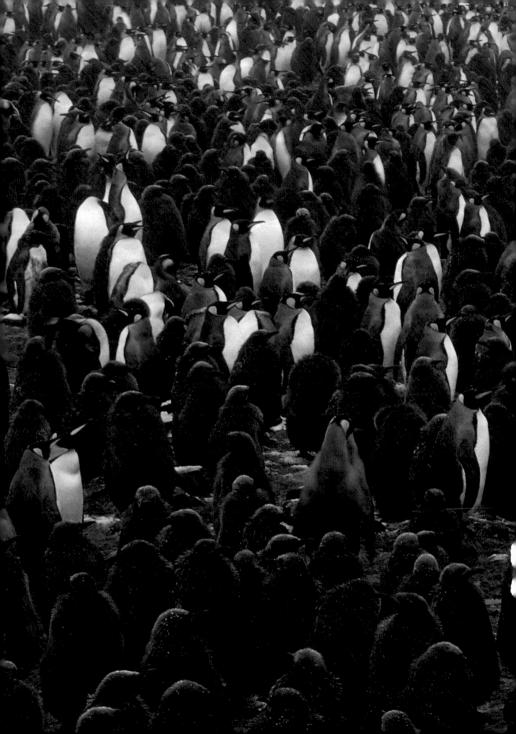

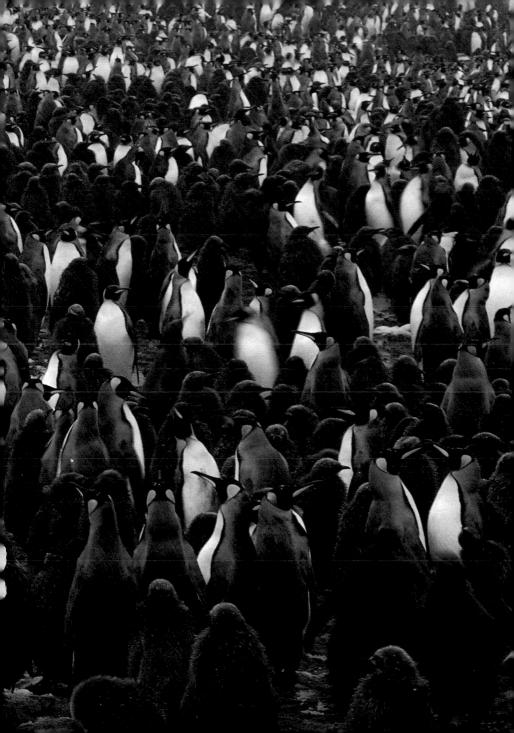

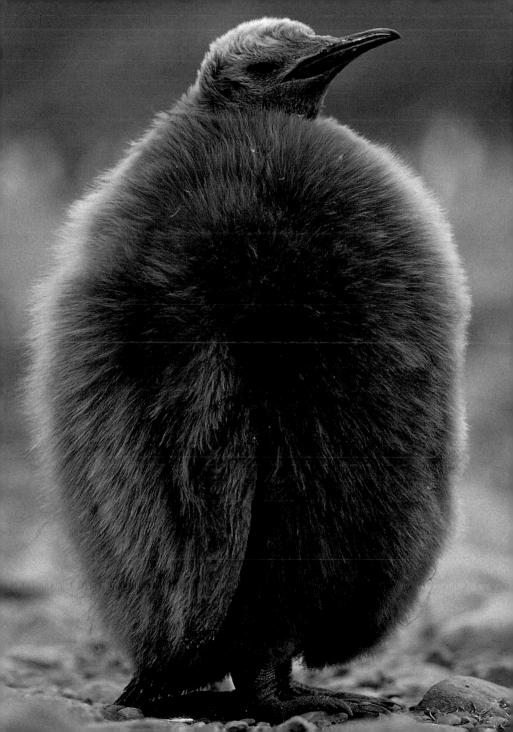

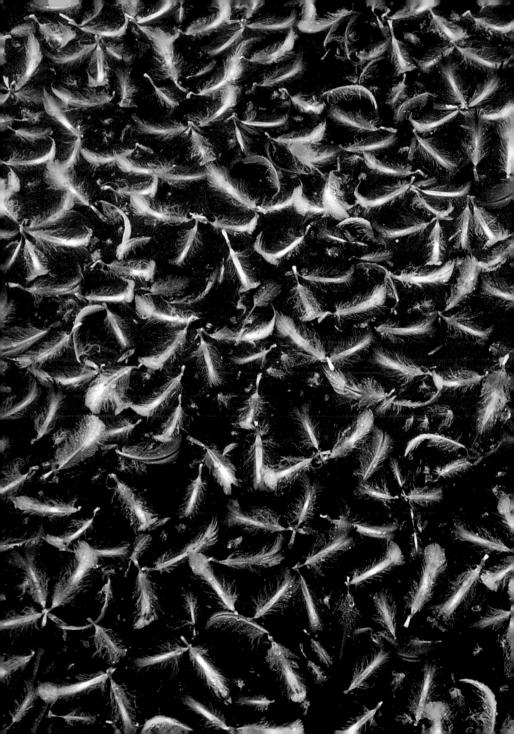

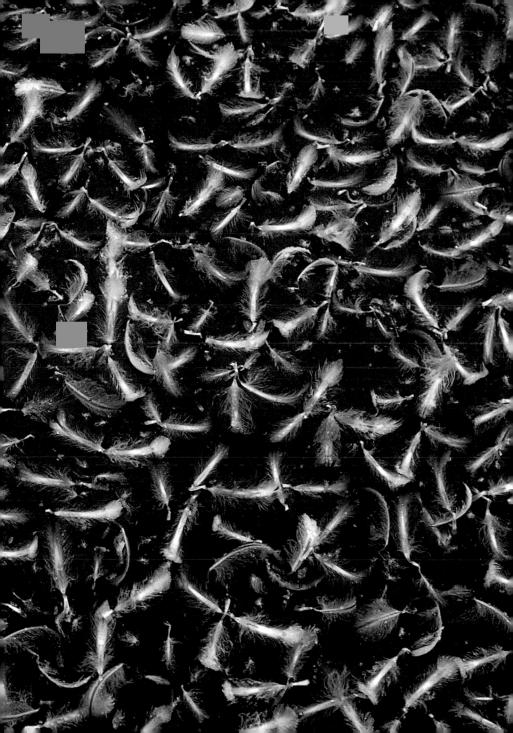

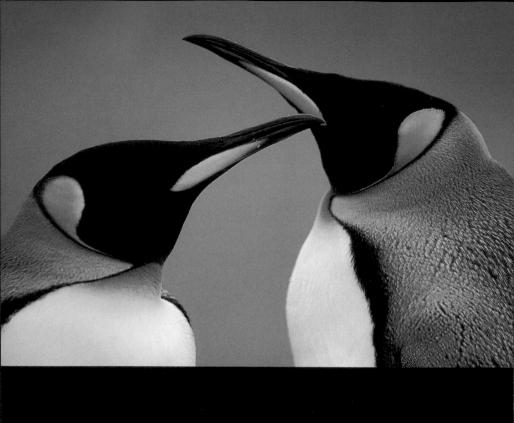

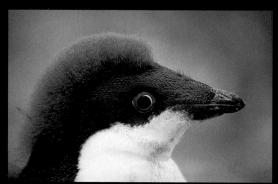

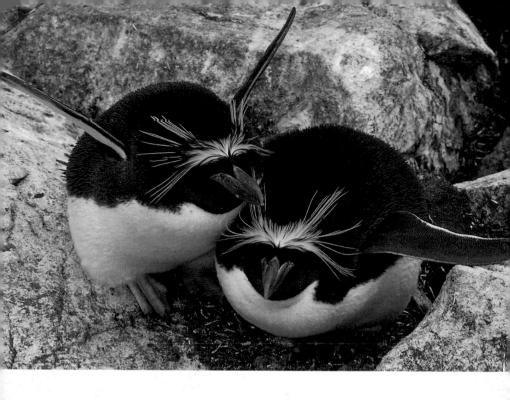

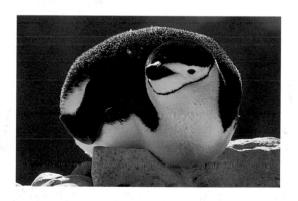

Top, left: King penguins, South Georgia Left: Adélie penguin chick, Antarctica Top: Macaroni penguins, South Georgia Above: Chinstrap penguin, South Georgia

Right: Macaroni penguin colony, South Georgia Following pages: Adélie penguins, South Sandwich Islands

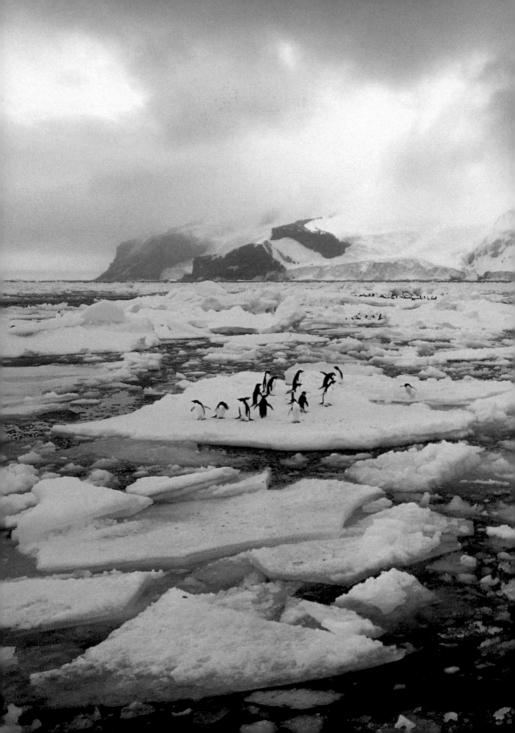

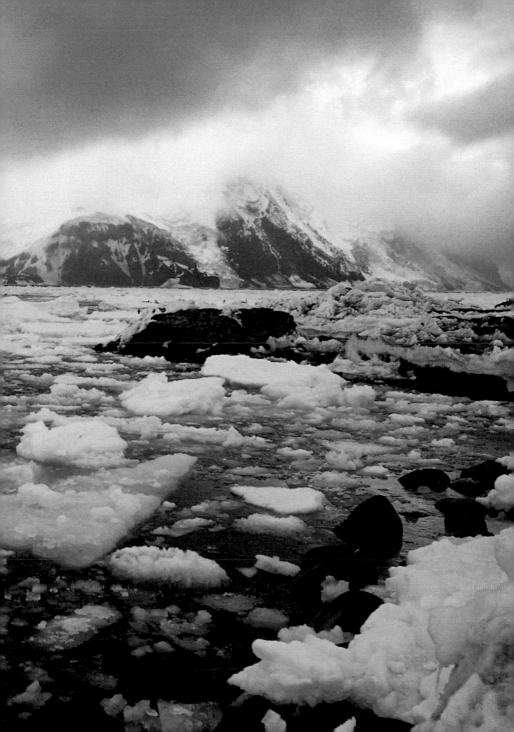

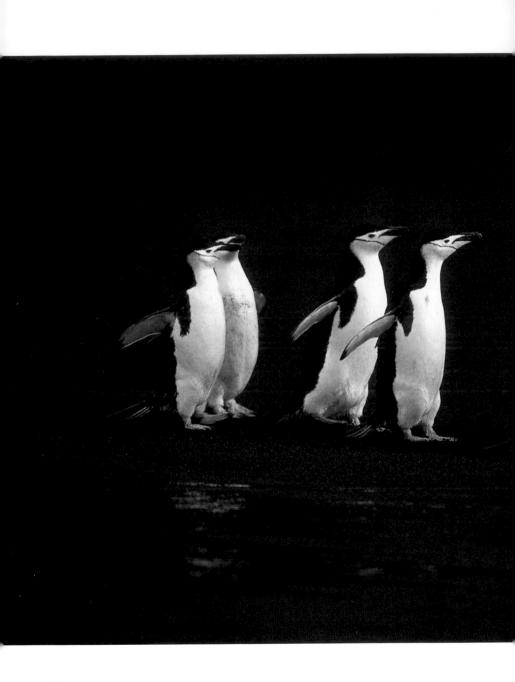

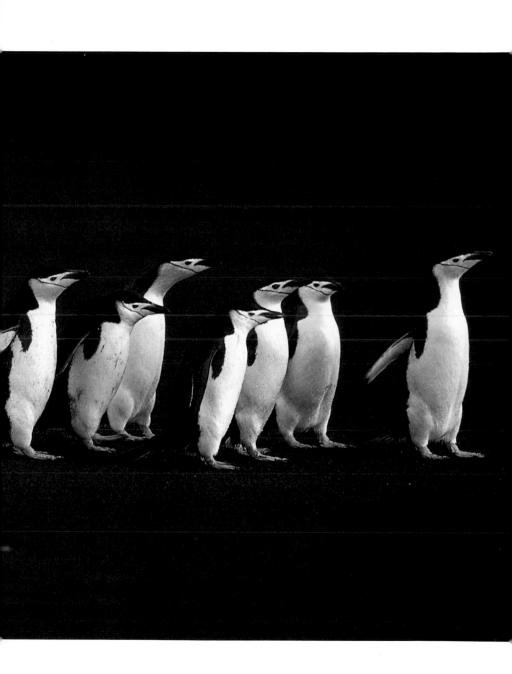

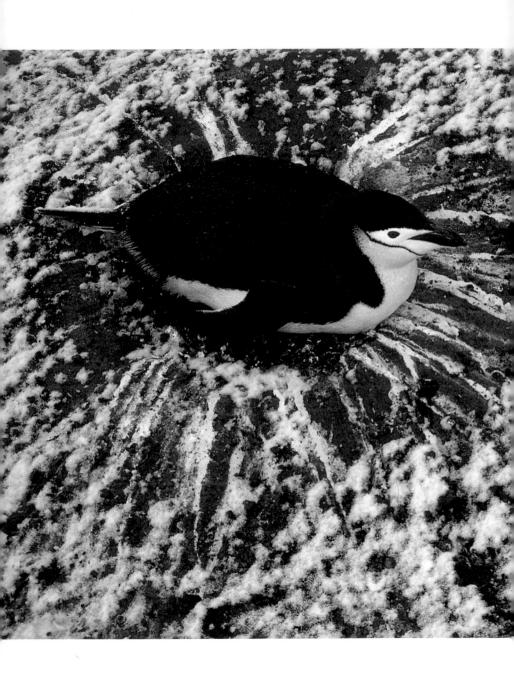

Preceding pages: Chinstrap penguins, Antarctica Left: Chinstrap penguin, South Orkney Islands

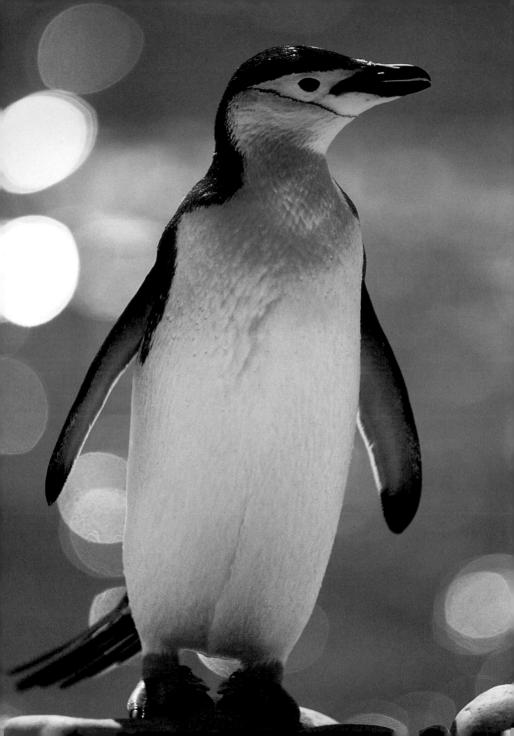

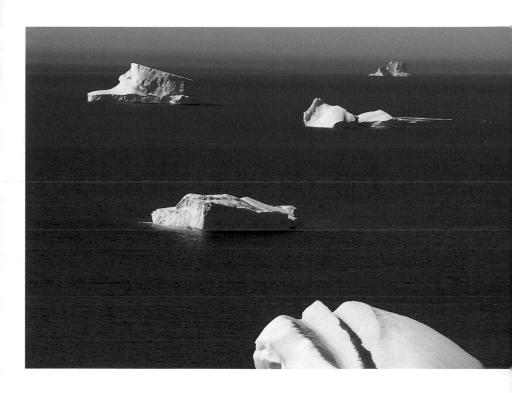

Left: Chinstrap penguin, South Georgia Above: Icebergs, Southern Ocean

Following pages: Chinstrap penguins, Southern Ocean

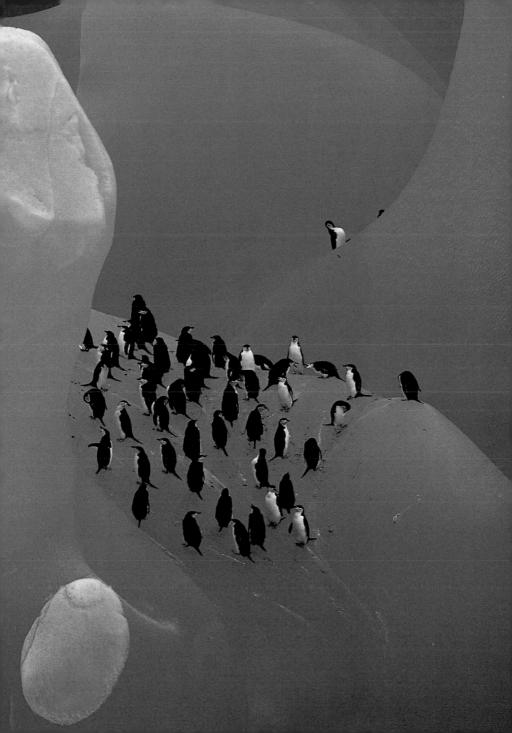

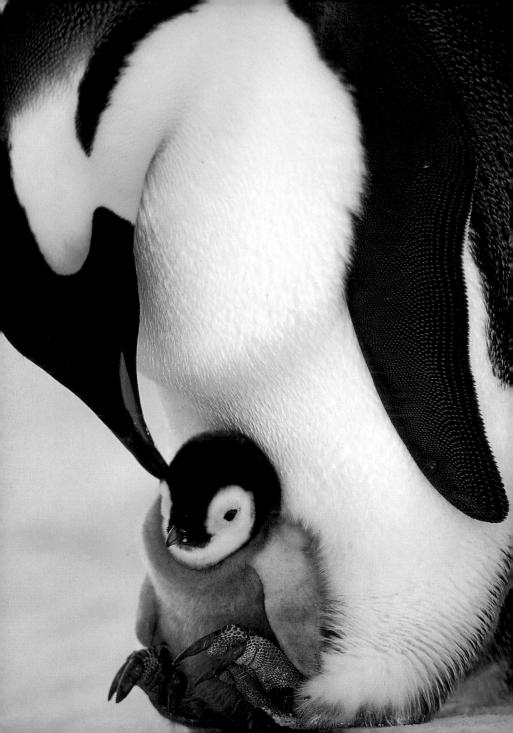

LIVING ON ICE

LIVING ON ICE

It hurts to breathe at minus 40° F, especially if you face into the wind. Even if you are an emperor penguin you have to hunch and huddle. If you are a human you have to hide. I am lying inside a tent holding on to the poles. The blizzard outside has pushed the ceiling down to a few inches above my nose. I am not sure this tent is going to make it. I am uncomfortably aware that only a thin membrane of nylon separates me from conditions I could not survive. Yet outside there are baby birds. They are emperor penguin chicks, and I am here to document their lives. I think of Edward Wilson, the biologist on Scott's 1910 South Pole expedition, who lost his tent in a horrible storm during the first expedition to seek out the gatherings of emperor penguins on the edge of Antarctica. He and two companions made a heroic trek to bring back proof that emperors raise young in midwinter. It took another 40 years before researchers were able to follow up on

Wilson's discoveries and conduct the first studies of these amazing birds.

Emperors are the ultimate penguins in many respects. They were the last to be discovered and they are the biggest of all. They weigh up to 90 pounds, twice as much as kings. They need that body mass as insulation against extremes of temperature and weather. Most emperors never touch solid ground in their lives. They almost always breed on sea ice, and spend the rest of their lives in freezing water. They dive down to 1,500 feet, deeper than any other bird, to pursue fish and squid in a frigid twilight zone. Since Wilson's time, this and much more has become known, but emperors still have the cachet of mystery and the unattainable. Only about 40 breeding colonies are known from the entire rim of the continent, and because of their remoteness, the emperor penguin remains the most difficult bird in the world to see.

Near my camp at the edge of Antarctica, where the Dawson-Lambton Glacier meets the Weddell Sea, an emperor penguin colony forms each austral winter.

The birds walk in from open sea across dozens of miles of sea ice. As the days darken to twilight, they court and mate.

Once each female lays her single egg, she transfers it to her partner and goes back to sea. In the depth of winter the males stand together, with eggs on their feet, incubating and fasting. They shelter each other in enormous huddles, packed so tight that ten adults can fit into one square yard. That cuts their heat loss in

half, but the birds are starved when the chicks are born on their feet in midwinter after two months of incubation. Miraculously their partners return just then to take over parental duties. The males, who have lost nearly half of their body weight, head to sea for their first meal in more than three months. From then on the parents take turns shuttling food for their offspring. Their breeding cycle is limed to launch young into the ocean at the height of summer, when an abundance of food gives them a head start. Yet that is what forces them to lay eggs during the unlikely time of midwinter.

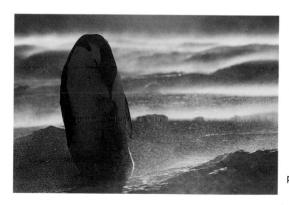

Page 110 and left: Emperor penguin and chick, Antarctica

The lives of emperors are linked to the waxing and waning of sea ice, which stretches like a membrane over the Weddell Sea and around the fringes of Antarctica. Sea ice is moved by winds from above and by sea currents from below. In the Weddell Sea it slowly turns with a clockwise current, and during summer long leads open up, especially near the eastern shores. They have lured in explorers like Sir Ernest Shackleton. He came in with his vessel *Endurance* in 1915, hoping to make it to the coast. Instead the ice closed in and crushed his ship, stranding his men. They spent a

hard winter on the ice, not far from the Dawson-Lambton Glacier, before they could escape. The emperor penguins they saw come and go, trudging back and forth to the sea, were probably ancestors of the same birds I am observing now.

Thousands of emperors are scattered across the ice. They sound like a symphony orchestra tuning up, with the breezy trumpeting of adults punctuating a chorus of chirping chicks. It is melodic, but there is an urgency to this concert as well. Each voice belongs to a bird searching for a parent or a chick. In other

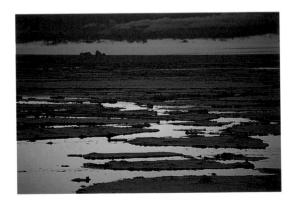

Right: Seascape, Antarctica Pages 116–121: Emperor penguins, Antarctica

penguins a territory serves as a home base where family members meet. In emperors the absence of territorial urges and aggressive impulses enables them to tolerate and shelter each other in the giant huddles of winter. Chicks huddle too, when parents are off foraging. An emperor colony is not governed by a territorial imperative; instead, there is an aural imperative for individuals to find each other on the basis of voice

When I walk away from the colony, silence sets in. The only sound I hear is the blood in my ears and the occasional crack of sea ice, a subtle reminder that this is a landscape of impermanence. It is early summer. The chicks still have a few weeks to go before they become independent. But if all goes as it has for ages, the sea ice will split open just long enough to allow a new generation of emperors to slip away before Antarctica closes again.

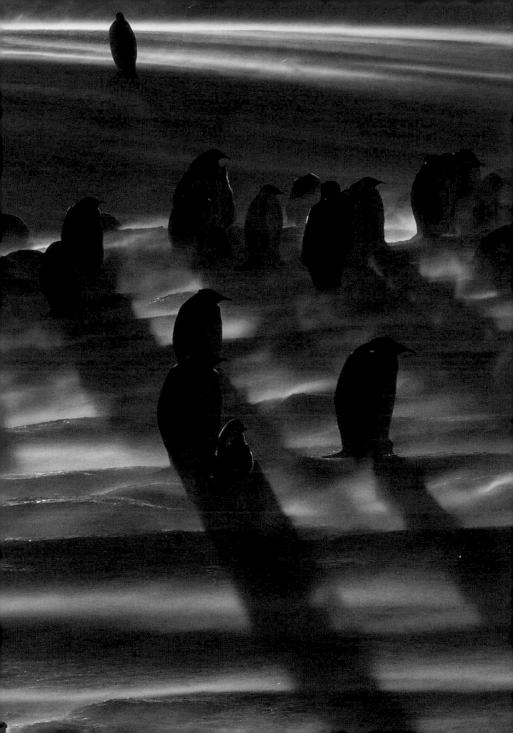

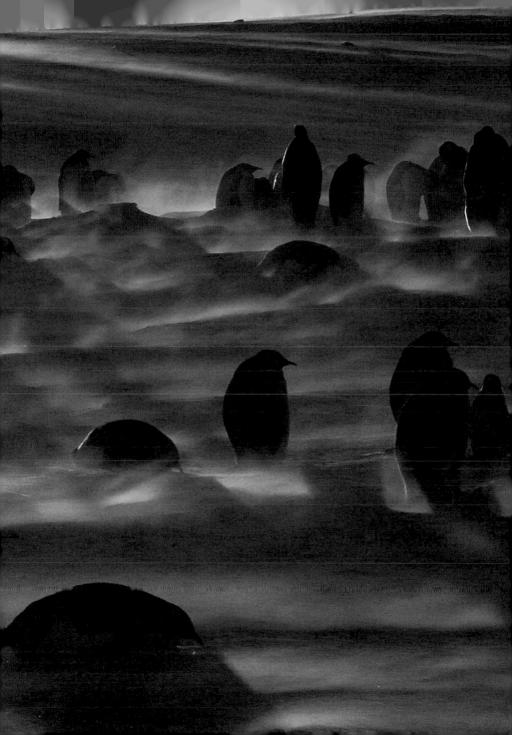

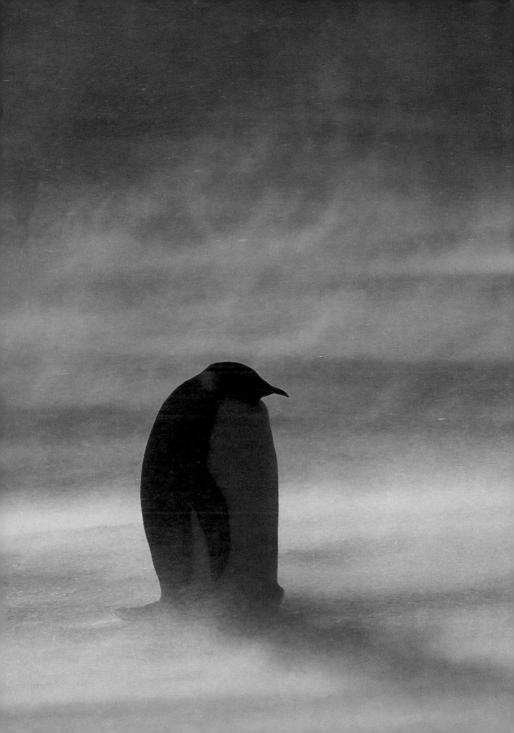

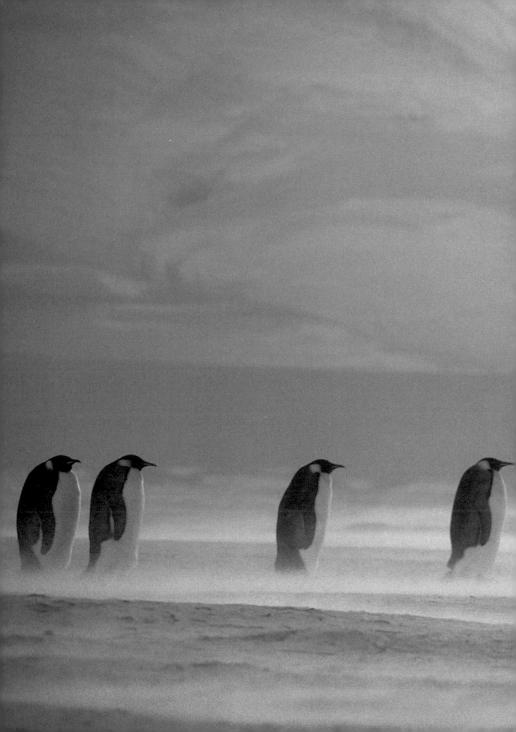

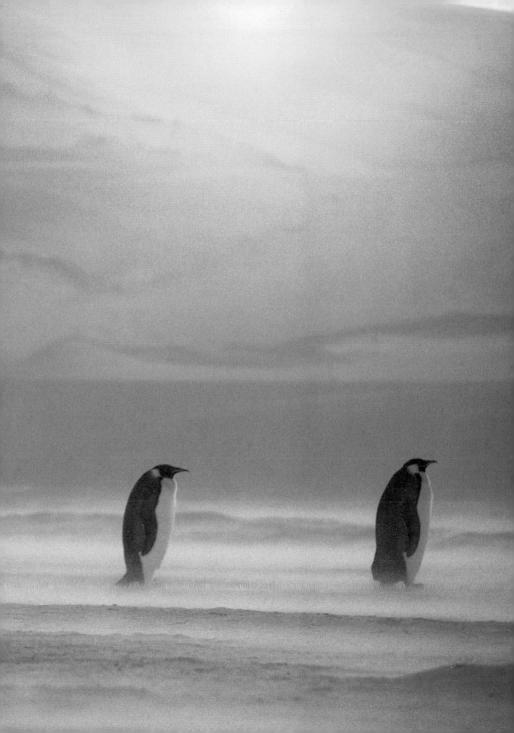

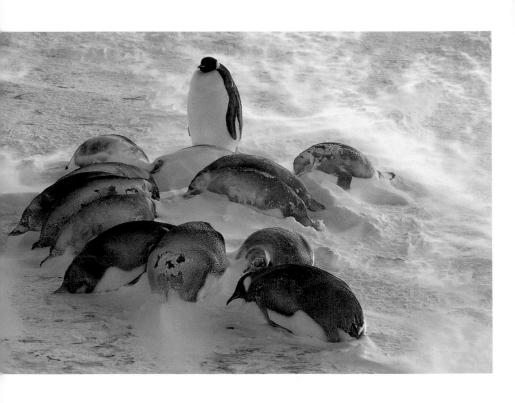

Above: Emperor penguins, Antarctica Right: Emperor penguin chick, Antarctica

Following pages: Emperor penguin huddle, Antarctica

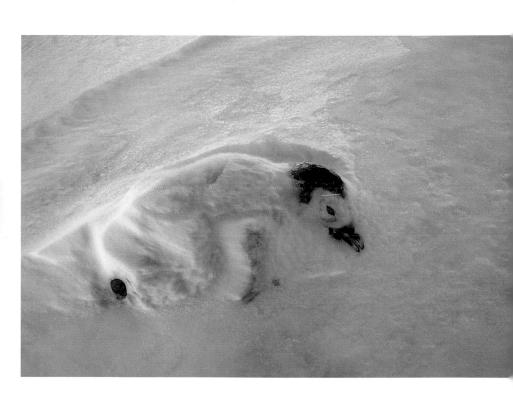

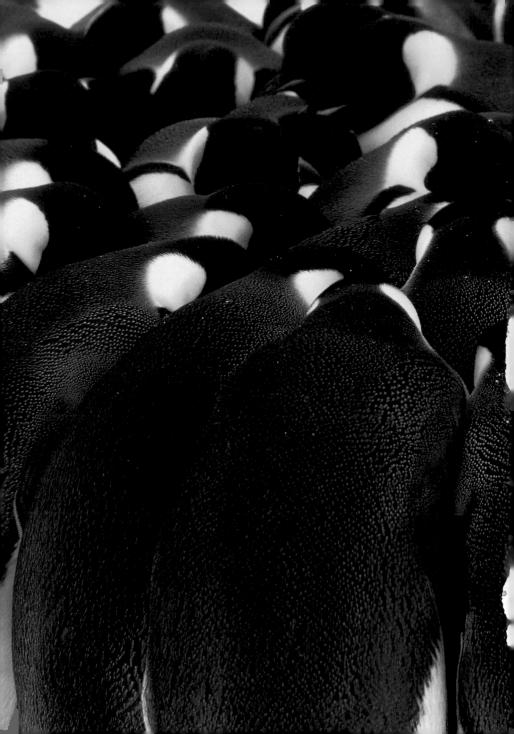

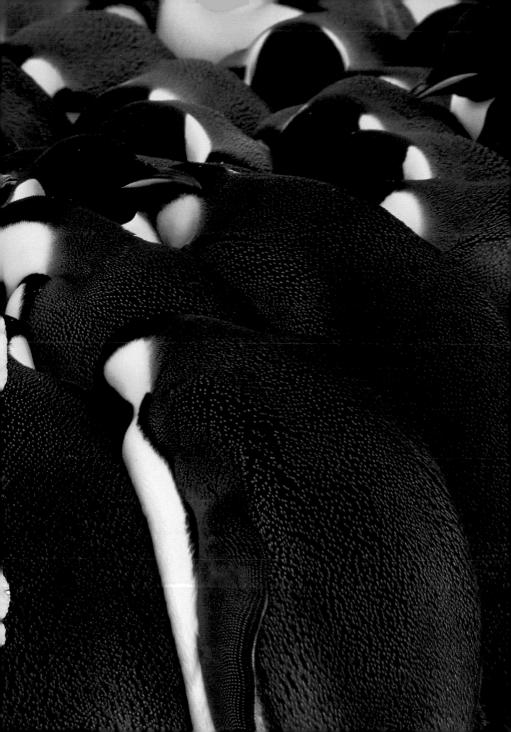

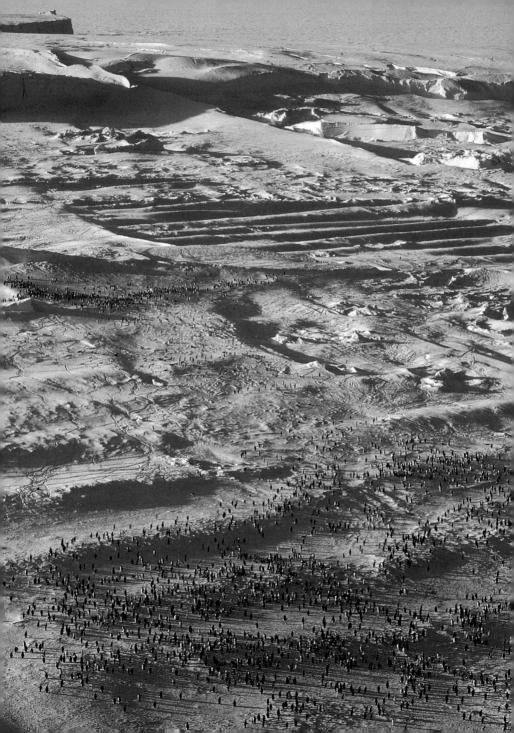

Left: Emperor penguin colony, Antarctica Pages 128–131: Emperor penguins, Antarctica

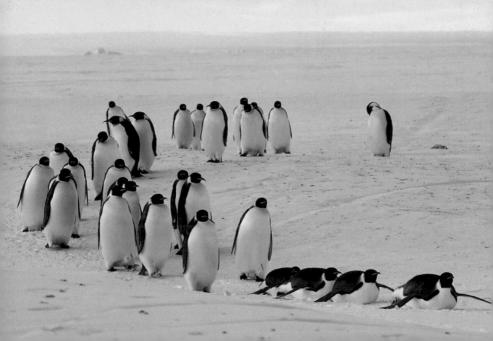

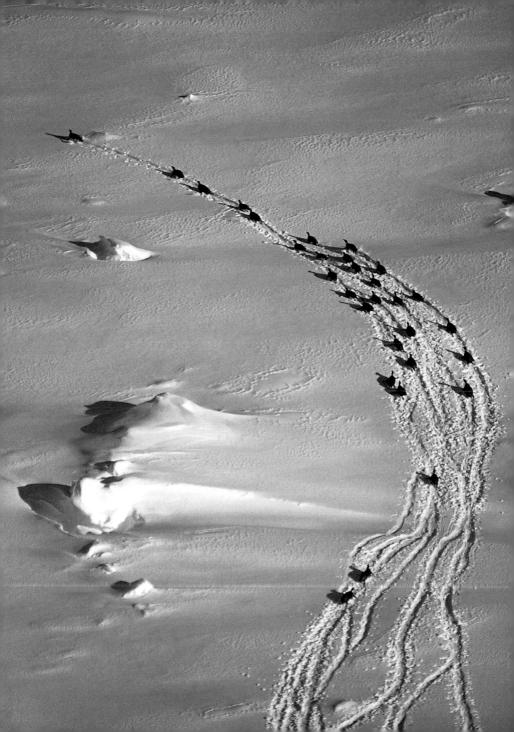

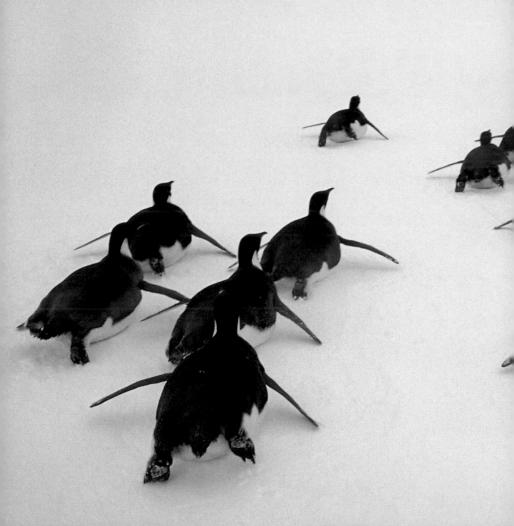

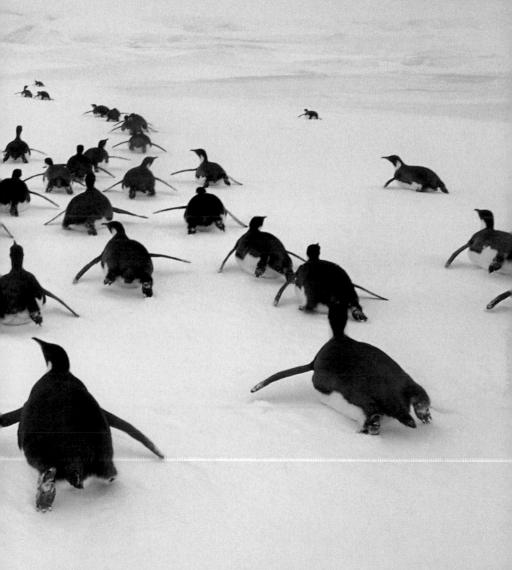

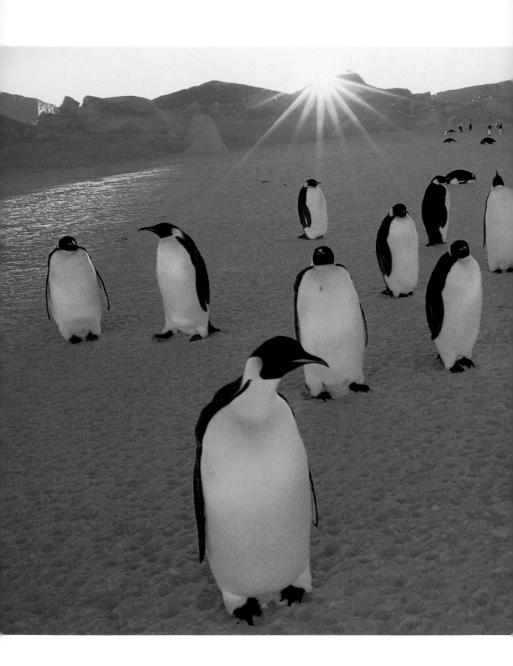

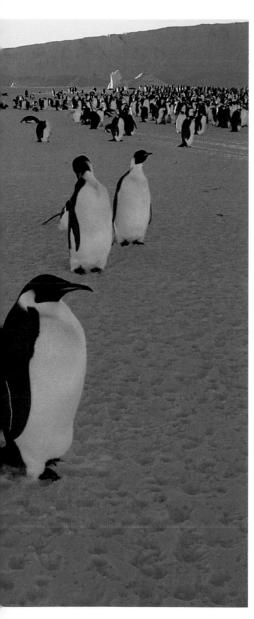

Left and following pages: Emperor penguin colony, Antarctica

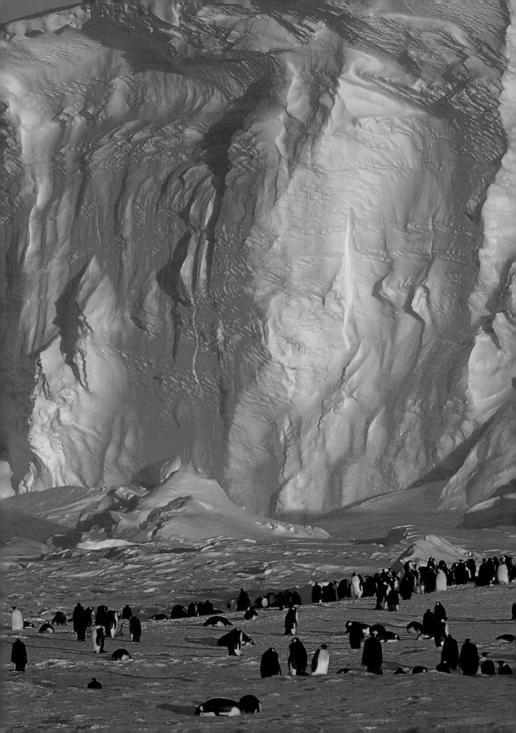

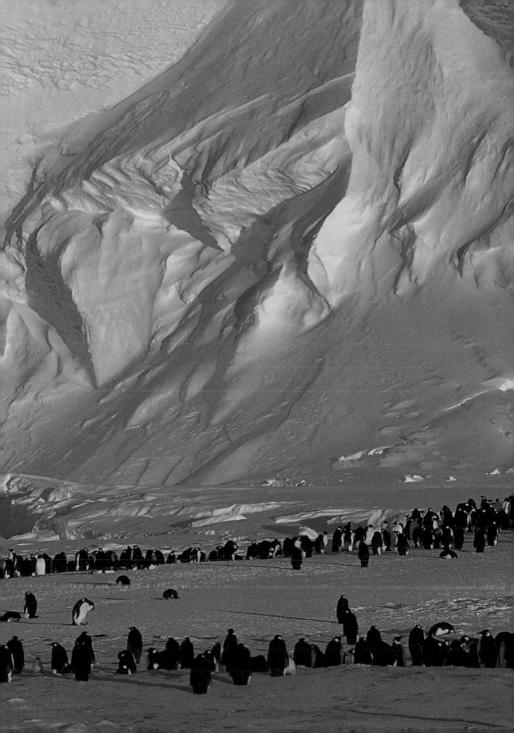

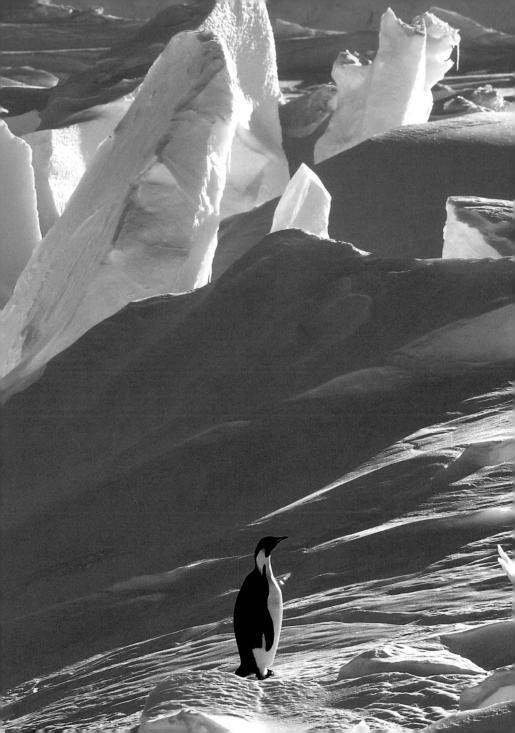

Left: Emperor penguin, Antarctica

Page 138: Emperor penguin chick, Antarctica

Page 139: Emperor penguin, Antarctica

Pages 140-141: Emperor penguin colony, Antarctica

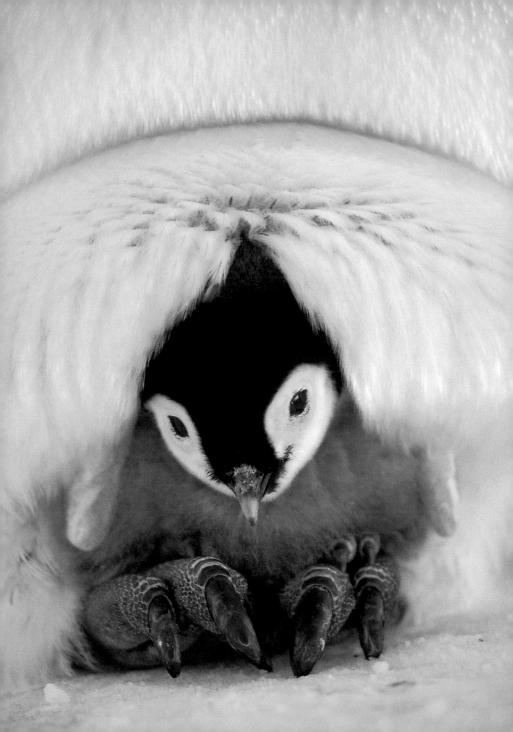

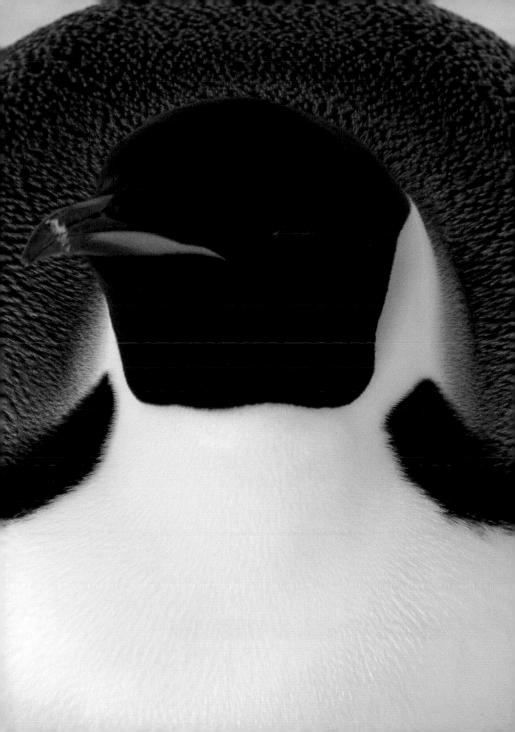

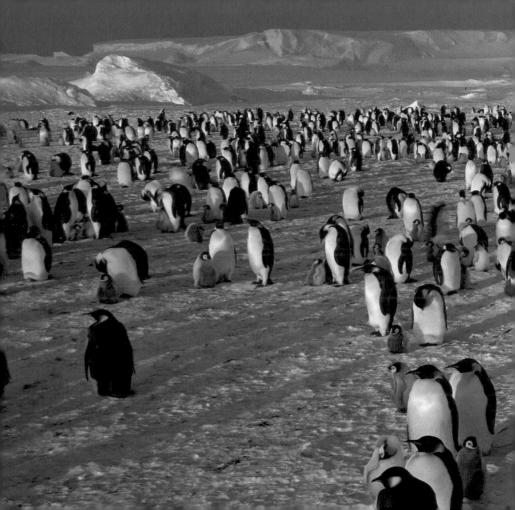

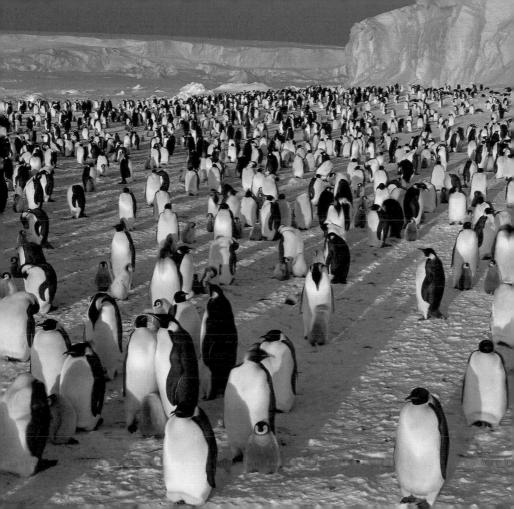

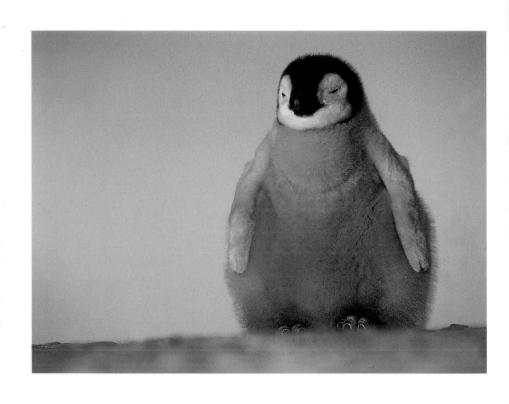

Above: Emperor penguin chick, Antarctica Right: Emperor penguin and chick, Antarctica Following pages: Emperor penguins and chick, Antarctica

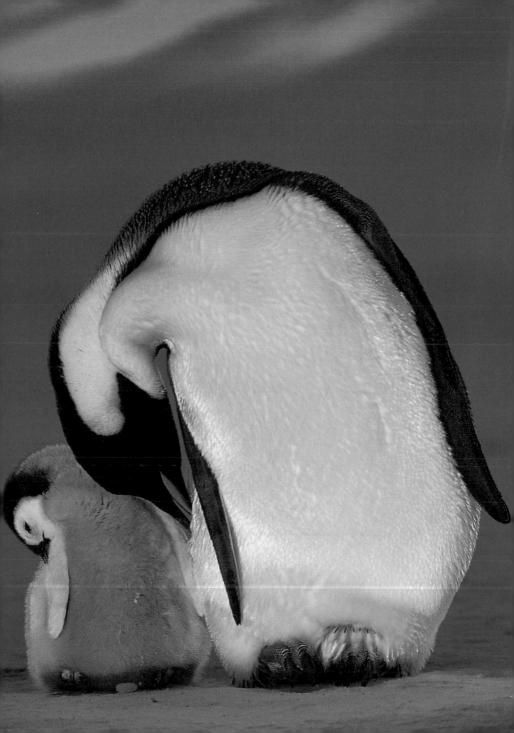

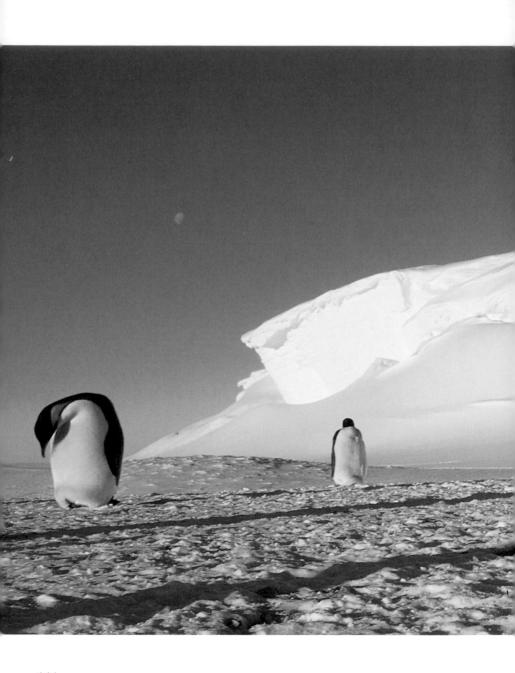

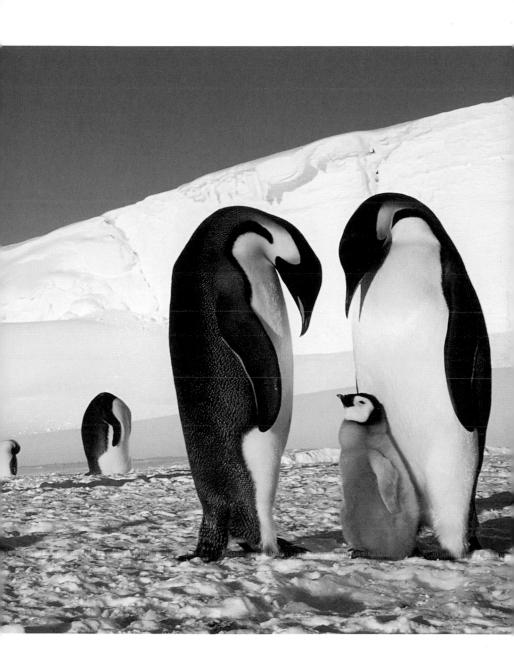

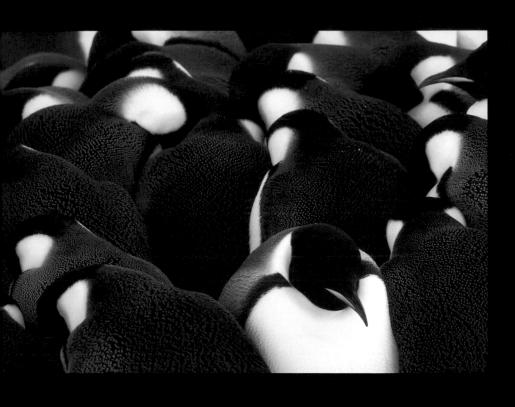

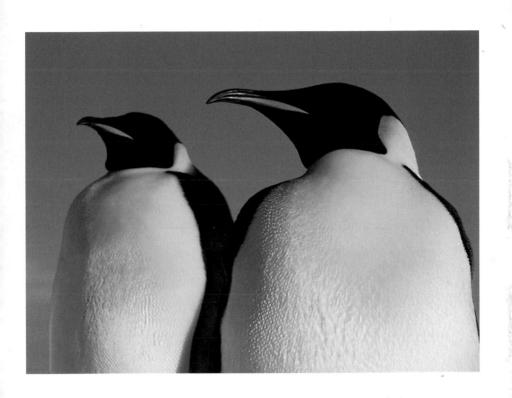

Left and above: Emperor penguins, Antarctica

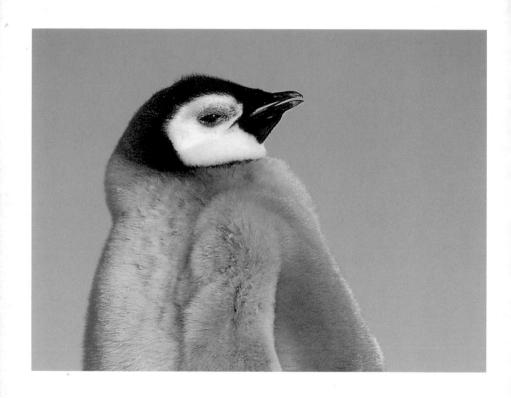

Above, right, and following pages: Emperor penguin chicks, Antarctica
Pages 152–153: Emperor penguin and chicks, Antarctica
Pages 154–155: Emperor penguin family, Antarctica,
Pages 156–157: Icescape, Antarctica

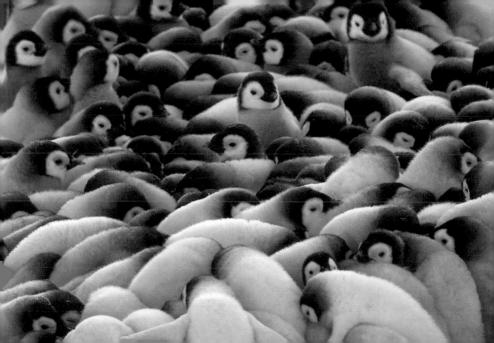

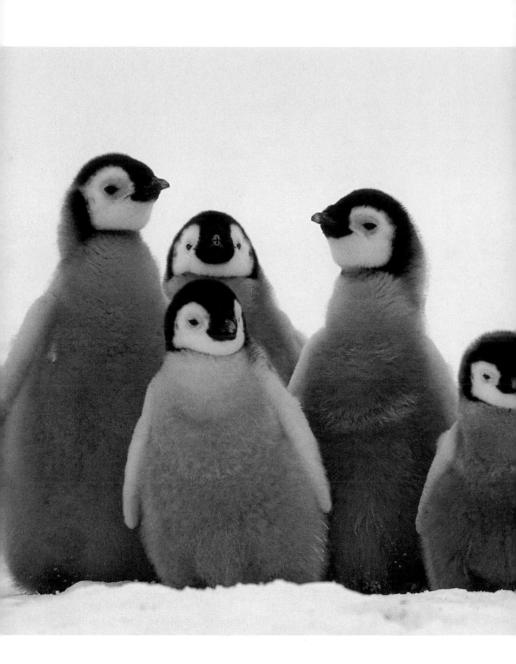

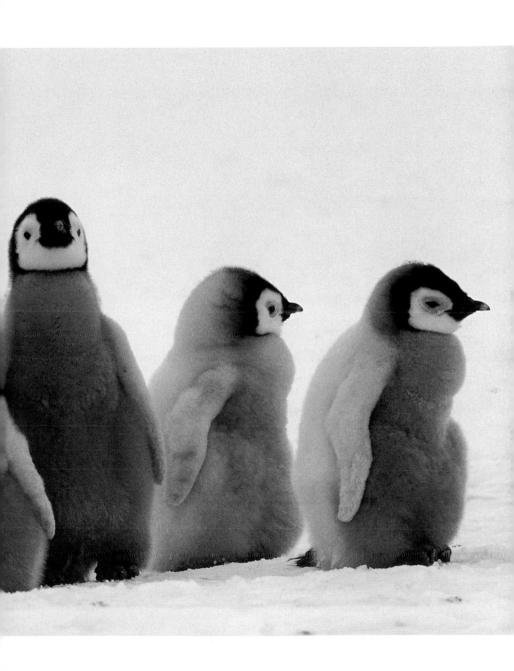

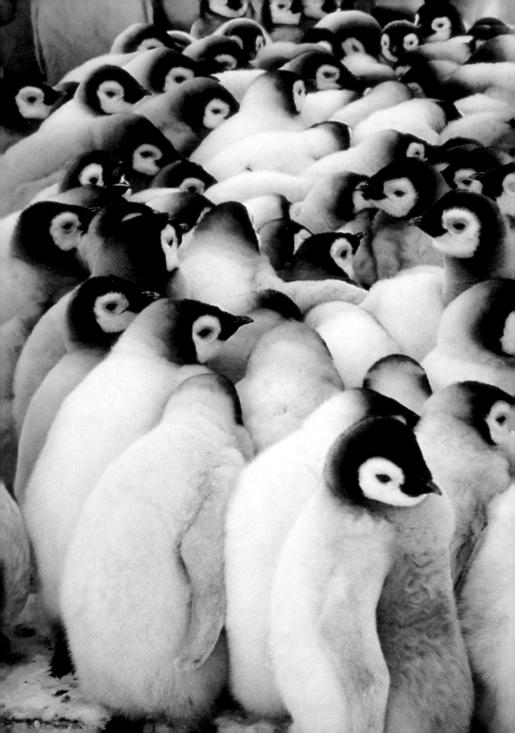

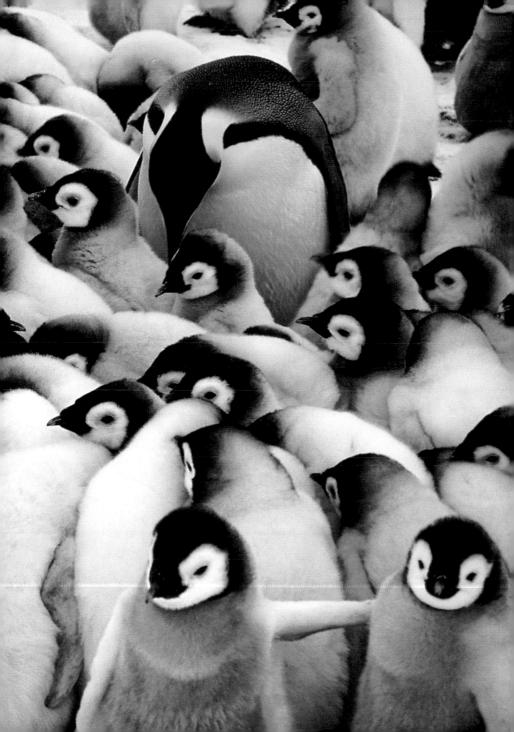

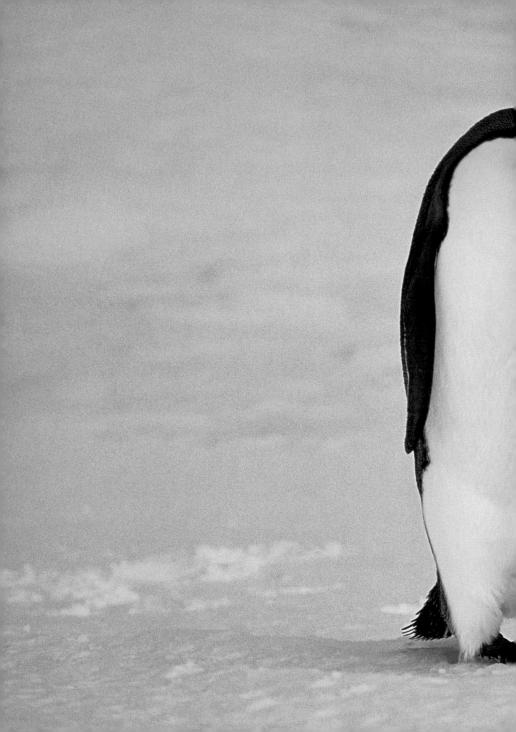

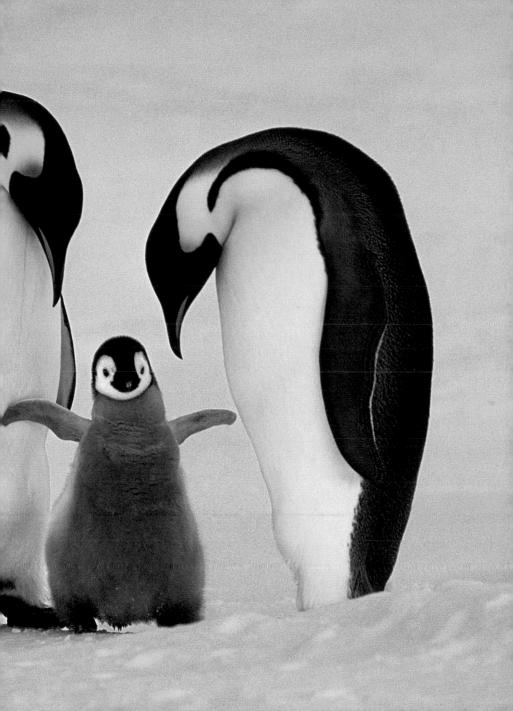

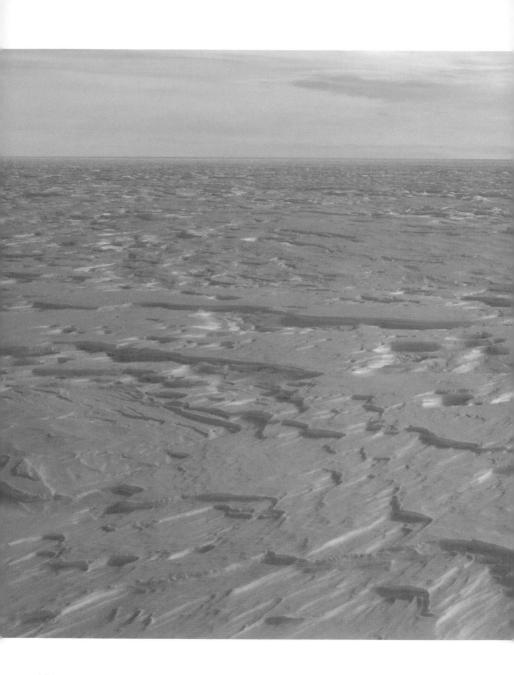

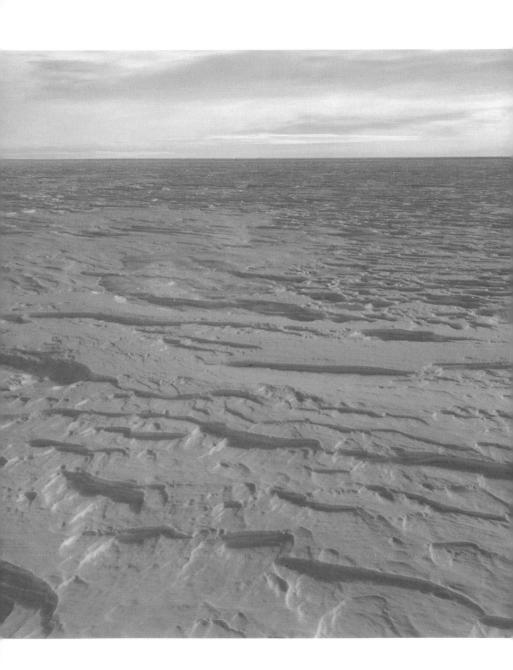

PHOTOGRAPHING PENGUINS

Many of the images in this book were made under remote conditions out at sea or while camping onshore where I could ill afford to break anything. Over years of fieldwork I have fine-tuned a system to protect my camera gear in hard plastic cases and padded backpacks. The cases are great for dubious air transfers, wet landings, snow storms, and cleaning fish. They protect the LowePro packs and bags I take into the field along with lightweight Gitzo carbofiber tripods and a basic survival kit. The majority of the

photos were made with a basic rig of two Nikon camera bodies and three Nikkor lenses: a 20mm wide-angle, an 80–200mm zoom, and a 300mm f/2.8 with extenders. A hand-held strobe worked wonders in low light.

At some point below minus 20°F, photography becomes painful. Film gets brittle, plastic breaks, and metal hurts to the touch. Under such extreme conditions I use a manual Nikon FM2 camera. Many of the emperor penguin photographs were made that way. Above minus 20°F, elec-

tronic cameras such as the Nikon N90s I use work well, especially with lithium batteries.

In the ten-year span covered by these images film technology has made remarkable advances. Modern transparency films such as Fuji's Velvia render the purity of Antarctic light at its most brilliant. Other films utilized for this book include older Kodachrome and newer Ektachrome emulsions, each of which serves a unique purpose. The inclement weather of the subantarctic

often calls for high-speed film. Sometimes
I deliberately use faster emulsions to influence the rendition of colors or contrast.

My favorite method for photographing penguins is simple. I go into a colony and look for a spot where I can sit among the birds without disturbing anyone. I let the neighborhood calm down. After some initial confusion about my presence, everybody soon goes back to more pressing business. That is when I can go about my business of photographing them. I use zoom lenses often, both in the

short and the long range, to minimize my own movements and for fast adjustments to unexpected events. In tight spaces I often use a monopod instead of a tripod, to be more mobile. I prefer to select a certain area and go back to it day after day, to get to know the habits of a small group of birds. After a while individual characters invariably emerge from the crowd.

The fearlessness of penguins, a characteristic they share with many wild animals who live unharassed on oceanic

islands, facilitates the intimate portrayal of animal life I pursue. Penguins are quite approachable, but photographing them can be trying. The colonies are muddy, smelly, and the weather can wear you down. Yet the experience of spending time among wild birds who take me for granted is endlessly satisfying. I enjoy their company as much as I enjoy the process of photographing them – and that is what my work is all about.

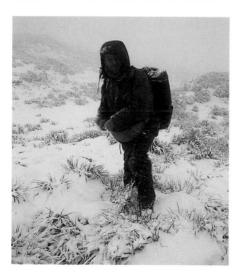

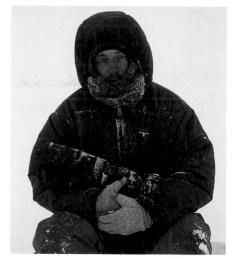

Preceding pages, left to right: Frans Lanting among chinstraps, Deception Island, (photograph by Kim Heacox); *Damien II*, off South Georgia; photographing emperors, Antarctica Left to right: Hiking South Georgia; on Antarctica; author's field camp, Weddell Sea

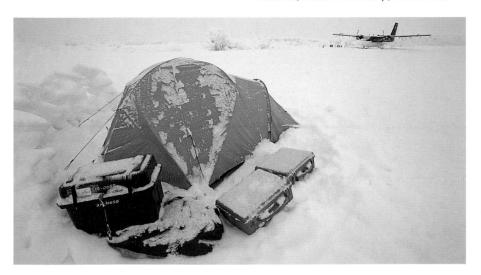

IMAGE INDEX

Penguin species featured in this book, in order of appearance:

Emperor penguin (Aptenodytes forsteri), Gentoo penguin (Pygoscelis papua), King penguin (Aptenodytes patagonicus), Galápagos penguin (Spheniscus mendiculus), Rockhopper penguin (Eudyptes chrysocome), Macaroni penguin (Eudyptes chrysolophus), Magellanic penguin (Spheniscus magellanicus), Adélie penguin (Pygoscelis adeliae), Chinstrap penguin (Pygoscelis antarctica)

Iceberg, South Georgia, p. 1

An iceberg frames the southern tip of South Georgia, where ocean currents from the Atlantic and the Antarctic mix, creating rich upwellings of marine life that sustain millions of penguins.

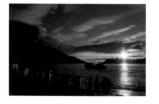

Gentoo penguins, South Georgia, pp. 2–3 Gentoos walk down a pebble beach glistening in the midnight sun over Stromness Bay.

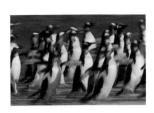

Gentoo penguins, Falklands, pp. 4–5 Panic-stricken gentoos streak across a beach on New Island, fleeing a sea lion attack.

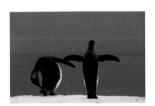

King penguins, South Georgia, pp. 6–7
King penguins preen and stretch on a snowy beach. Their genus name, Aptenodytes, means "featherless diver," and dates from a time when penguin plumage was believed to be unique. It is actually no different in structure from that of any other bird, but the short, stiffened, and flat quality of penguin feathers is especially well-suited to life in cold waters.

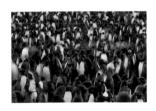

King penguins, South Georgia, pp. 8–9 King penguins of all ages are gathered at twilight on a stony slope below a glacier in St. Andrews Bay.

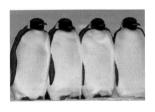

Emperor penguins, Antarctica, pp. 10–11 Four emperors share evening sun and body heat on a bitter cold day.

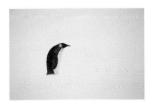

Emperor penguin, Antarctica, pp. 12–13 A lone emperor trudges through a blizzard.

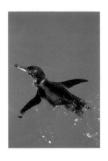

Galápagos penguin, Galápagos Islands, p. 17 The rarest penguin in the world, a Galápagos penguin paddles through the turquoise water of a shallow inlet on Fernandina Island.

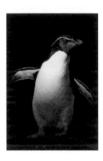

Rockhopper penguin, Falklands, p. 20
Fresh from the sea, a rockhopper shakes dry before marching inland.

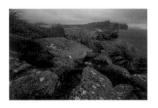

Landscape, Falklands, p. 22 Lichen-covered rocks and tall tussock grasses shelter penguins and other birds. Tilted sea cliffs in the distance are a nesting area for thousands of rockhoppers.

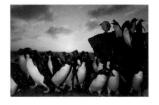

Rockhopper penguins, Falklands, p. 25 A mob of rockhoppers crowds an intertidal rock where they have just scrambled ashore.

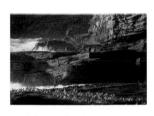

Rockhopper penguins, Falklands, pp. 26–27 Rockhoppers stream across a rocky shelf to start their climb to colonies inland.

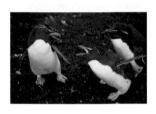

Rockhopper penguins, Falklands, p. 28 Two male rockhoppers contest a narrow passage in a crowded colony.

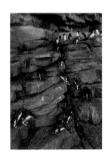

Rockhopper penguins, Falklands, p. 29 Claw marks made by generations of passing penguins are visible in a cliff face traversed by rockhoppers on their way to a large breeding colony.

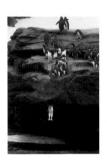

Rockhopper penguins, Falklands, p. 31 A rockhopper makes a daring leap, watched by others not yet convinced to follow.

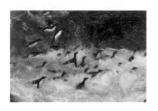

Macaroni penguins, South Georgia, pp. 32–33 Macaronis catapult ashore from a wave crashing in a narrow cove at the northern tip of South Georgia, where millions of these small penguins nest.

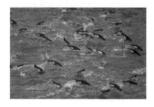

Macaroni penguins, South Georgia, pp. 34–35 Porpoising allows macaroni penguins to travel at high speed near the water surface off the northern tip of South Georgia.

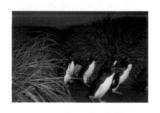

Rockhopper penguins, Falklands, pp. 36–37 Homeward-bound rockhoppers trudge through a landscape dominated by tussock grass.

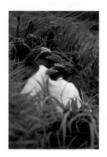

Macaroni penguins, South Georgia, p. 38 A courting pair of macaronis shelters in the lee of a tussock slope on Bird Island, off the northern tip of South Georgia.

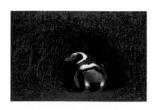

Magellanic penguin, Falklands, p. 39
A penguin with underground nesting habits, a Magellanic peers from a burrow he has excavated in a slope of soft soil.

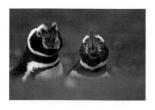

Magellanic penguins, Falklands, p. 40 (top) Two Magellanics calling from their burrow show barb-lined mouths that can grip slippery fish.

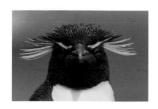

Rockhopper penguin, Falklands, p. 40 (bottom) Erect yellow plumes are an indication of breeding prowess, and they can give a male rockhopper an edge over his rivals in the mating game.

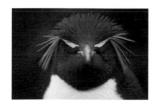

Rockhopper penguin, Falklands, p. 41 (top) A male rockhopper lets his plumes down as a sign of relaxation.

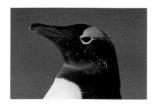

Gentoo penguin, Falklands, p. 41 (bottom) White flashes above their eyes are a characteristic feature of adult gentoos.

Striated caracaras, Falklands, pp. 42–43
A huge colony of rockhopper penguins mixed with albatrosses sustains predatory birds like these striated caracaras (*Phalcoboenus australis*) on Beauchêne, a remote isle in the southern Falklands.

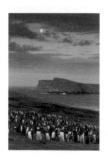

Gentoo penguins, Falklands, p. 45 Light from a setting sun and a rising moon washes over a pasture filled with nesting gentoos.

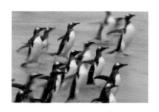

Gentoo penguins, Falklands, pp. 46–47 Gentoos rush ashore after a day at sea.

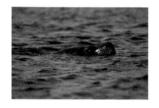

Southern sea lion, Falklands, p. 48 A male sea lion *(Otaria flavescens)* keeps a low profile as he cruises for penguins in the shallows.

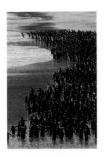

Gentoo penguins, Falklands, p. 49 Gentoo penguins mass along the tide line, scanning the surf for signs of danger.

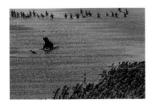

Southern sea lion and gentoo penguins, Falklands, pp. 50-51

In a rare onshore attack, a sea lion bursts onto the beach to launch a running assault on a flock of gentoo penguins, who scatter in all directions. One extremely lucky penguin escapes with a desperate last-second dodge.

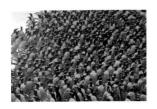

Gentoo penguins, Falklands, pp. 52–53 Seeking safety in numbers, gentoo penguins scramble to get away from a sea lion.

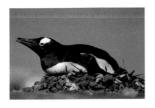

Gentoo penguin, Falklands, pp. 54–55 A male gentoo penguin incubates on a pebble-lined nest garnished with feathers.

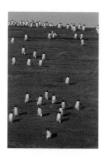

Gentoo penguins, Falklands, p. 56 Fishing parties of gentoos head inland to feed their chicks in late afternoon.

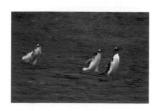

Gentoo penguins, Falklands, p. 58 Two chicks pursue an adult gentoo for the fresh krill it carries in its crop.

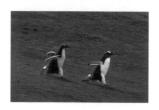

Gentoo penguins, Falklands, p. 59 A nearly full-grown chick closes in on a parent for a meal.

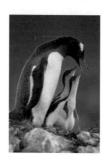

Gentoo penguins, South Georgia, p. 61 Two-week-old chicks peck at a gentoo parent's bill, begging for food.

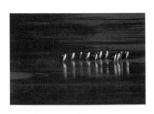

Gentoo penguins, Falklands, pp. 62–63 A flock of gentoo penguins returns home after a day of fishing the seas around the Falklands, where one-third of the world's gentoos nest.

Gentoo penguins, Falklands, pp. 64–65 A flotilla of gentoo penguins bobs offshore. Unlike other penguins that may venture hundreds of miles out to sea on long fishing trips, gentoos usually feed within 15 miles of land.

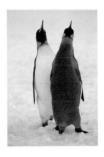

King penguins, South Georgia, p. 66 King penguin partners stand tall and point bills to the sky in an ecstatic courtship display.

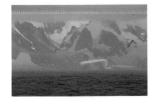

North coast, South Georgia, p. 69 Low clouds and foul weather often obscure South Georgia, where colonies of many thousands of king penguins gather each year along coastal plains and sheltered bays.

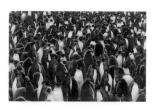

King penguins, South Georgia, p. 71 King penguins of all ages crowd a colony.

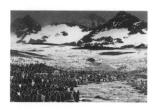

King penguins, South Georgia, pp. 72–73
Half-grown chicks line up along a glacial stream flowing down from mountains that rise nearly 10,000 feet above St. Andrews Bay.

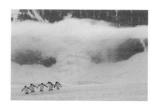

King penguins, South Georgia, pp. 74–75 With flippers held out for balance, a courting party of kings ambles across a snowfield.

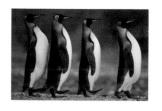

King penguins, South Georgia, pp. 76–77
King penguins strut during a characteristic courtship display that involves one partner leading another in a stiff-backed walk while the head sways from side to side. Such displays often prompt other unpaired birds to join in.

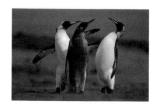

King penguins, South Georgia, p. 78 and p. 79 A lone female king penguin tries to edge in on a courting pair and is reproached with wild flipper whacking from her female rival.

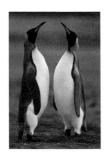

King penguins, South Georgia, p. 80 Courtship display in king penguins includes a face-off by prospective partners who mirror each other's body movements, alternately stretching tall, relaxing, and moving their bills in synchrony.

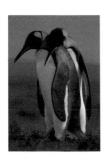

King penguins, South Georgia, p. 81 In advanced courtship, a male king penguin makes body contact with a female, leaning against her and hooking his head over her shoulder.

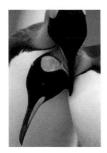

King penguins, South Georgia, p. 83 Just before mating, a male may press his head on the female's shoulder and rub her neck with his bill.

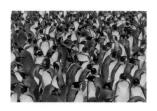

King penguins, South Georgia, pp. 84–85 Even in a densely packed colony, king penguins maintain territories where male and female meet up and swap incubating and chick-rearing duties.

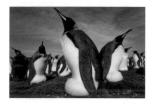

King penguins, Falklands, pp. 86–87 Both male and female king penguins incubate eggs, which they hold on their feet. A fold of belly skin extends over the egg, keeping it warm.

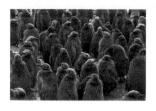

King penguins, South Georgia, p. 88 Half-grown king penguin chicks wait in freezing rain for parents to return from sea.

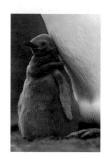

King penguin, South Georgia, p. 89
A newborn king penguin chick faces more than 16 months of dependency on its parents, a length of time equaled only by wandering albatrosses and California condors.

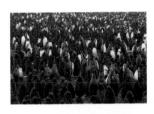

King penguins, South Georgia, pp. 90–91 Adults and chicks mingle in a colony pelted by summer sleet.

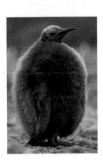

King penguin, South Georgia, p. 93 Two-thirds grown, a king penguin chick has amassed the thick down and body fat needed to survive a winter of nearstarvation under frigid conditions.

King penguin feathers, South Georgia, pp. 94–95 Molted feathers float in a tidal pool at St. Andrews Bay.

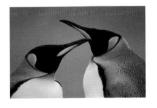

King penguins, South Georgia, p. 96 (top)
Male and female king penguins show off bright orange cheek
patches, important signals of prime breeding condition.

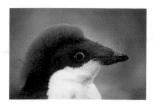

Adélie penguin, Antarctica, p. 96 (bottom) In late summer a juvenile Adélie molts its fluffy chick down to reveal the black-and-white plumage of adulthood.

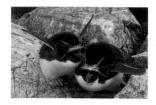

Macaroni penguins, South Georgia, p. 97 (top)
A macaroni penguin stands guard by its partner, who incubates an egg on a nest that is little more than a flat spot among the rocks.

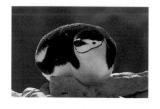

Chinstrap penguin, South Georgia, p. 97 (bottom)
A resting chinstrap penguin draws its flippers close to retain heat.

Macaroni penguins, South Georgia, p. 99
On a hillside devoid of vegetation an immense colony of macaronis rises from the sea. Birds nesting near the top face an hour-long hike each time they come ashore.

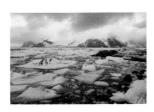

Adélie penguins, South Sandwich Islands, pp. 100–101 Even in summer the South Sandwich Islands are surrounded by sea ice, which these Adélies use as a diving platform.

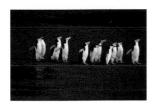

Chinstrap penguins, Antarctica, pp. 102–103
Chinstraps pause on a beach of black volcanic sand on
Deception Island, off the Antarctic peninsula. They are one of
the most numerous species of penguins, and some colonies
have been estimated at more than five million birds.

Chinstrap penguin, South Orkney Islands, pp. 104–105 A chinstrap incubates on a nest ringed by excretion patterns.

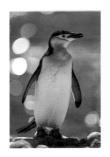

Chinstrap penguin, South Georgia, p. 106 A chinstrap shows his brushy tail as he stands on a cobblestone beach to dry in the sun.

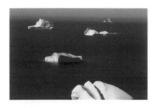

Icebergs, Southern Ocean, p. 107 Icebergs calved from glaciers and ice shelves in Antarctica melt as they slowly drift north. Most vanish within two years.

Chinstrap penguins, Southern Ocean, pp. 108–109 Chinstrap penguins find a haul-out among the spired contours of a huge iceberg. Dense ice compressed by years of snowfall can turn a brilliant blue.

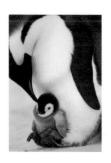

Emperor penguins, Antarctica, p. 110 An emperor cradles its newborn chick on its feet to keep it from getting chilled.

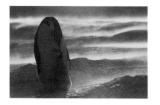

Emperor penguins, Antarctica, p. 113 An emperor chick calls to a parent in a howling blizzard on sea ice off Antarctica.

Seascape, Antarctica, p. 114
When the Weddell Sea ice pack breaks up in early summer, open leads appear close to the coastline of the continent, creating passages used by emperor penguins to travel back and forth to their colonies.

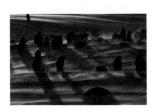

Emperor penguins, Antarctica, pp. 116–117 With stoic endurance, emperor penguins brace against a blizzard. In wintertime they face winds of more than 100 miles an hour and temperatures that drop to minus 70° F.

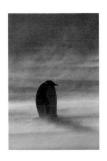

Emperor penguin, Antarctica, p. 118
With neck drawn in, back hunched against the wind, and flippers pressed tightly against its body, an emperor penguin minimizes heat loss.

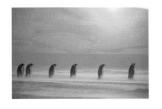

Emperor penguins, Antarctica, pp. 120–121 A procession of emperors walks through a valley flanked by enormous icebergs during a storm.

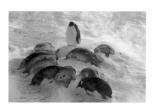

Emperor penguins, Antarctica, p. 122 Looking like fallen soldiers, emperor penguins lie down to sleep in the aftermath of a blizzard that lasted for two days.

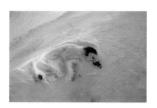

Emperor penguin, Antarctica, p. 123
A frozen emperor penguin chick attests to the harsh conditions under which these birds grow up. More than three-fourths of each generation often perish before fledging.

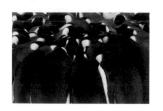

Emperor penguins, Antarctica, pp. 124–125
By huddling together emperor penguins can cut their heat loss by more than 50 percent. During winter, huddles of more than 1,000 incubating males form. Without this unique adaptation, they would not be able to survive the brutal weather.

Emperor penguins, Antarctica, p. 126 An emperor penguin colony peppers the frozen surface of the Weddell Sea.

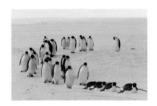

Emperor penguins, Antarctica, p. 128

Emperor penguins alternate between walking and tobogganing on their bellies as they make their way across sea ice to open water.

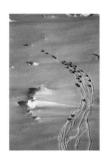

Emperor penguins, Antarctica, p. 129

Emperor penguins paddle through deep snow on one of their long journeys between colony and open sea. Some colonies can be as far as 100 miles from open water.

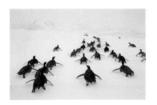

Emperor penguins, Antarctica, pp. 130-131

Emperor penguins use their clawed feet like crampons to propel themselves on ice.

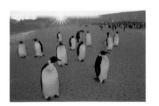

Emperor penguins, Antarctica, pp. 132-133

A springtime sun rises over a scattered colony of emperor penguins.

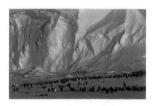

Emperor penguins, Antarctica, pp. 134–135 A huge ice wall marks the edge of the Antarctic continent and serves as a windbreak for a colony of emperors.

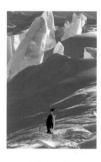

Emperor penguin, Antarctica, p. 136 An emperor penguin pauses to search for the best way through a contorted icescape of pressure ridges.

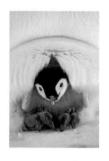

Emperor penguin, Antarctica, p. 138 A newborn emperor penguin chick is snuggled on its parent's feet. A skin flap folds over the baby to protect it from intense cold. It will be brooded for 50 days.

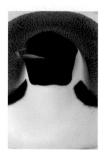

Emperor penguin, Antarctica, p. 139 A head-on view of an emperor penguin shows the overlapping layers of its outer plumage.

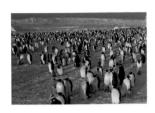

Emperor penguins, Antarctica, pp. 140–141
A panoramic view shows the emperor penguin colony that forms each year at the edge of the Dawson-Lambton Glacier and the Weddell Sea.

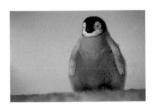

Emperor penguin, Antarctica, p. 142 A content-looking emperor penguin chick is filled to capacity after a huge meal of fish and squid regurgitated by a parent. They can be fed several pounds per feeding.

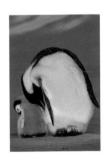

Emperor penguins, Antarctica, p. 143
An emperor penguin chick mimics its parent and preens feathers.

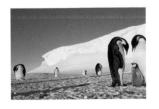

Emperor penguins, Antarctica, pp. 144–145 In the otherworldly light cast by a setting Antarctic sun, two emperor penguin parents meet up with their offspring at the edge of a stranded iceberg.

Emperor penguins, Antarctica, p. 146 Hunched and huddled, emperors stay close for warmth on a bitter cold evening.

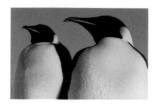

Emperor penguins, Antarctica, p. 147 In outward appearance emperor penguin males and females are virtually indistinguishable, although males are often slightly taller.

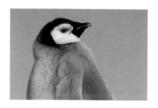

Emperor penguin, Antarctica, p. 148 A side view of an emperor penguin chick reveals the white cheeks that distinguish it from chicks of all other penguin species.

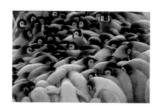

Emperor penguins, Antarctica, p. 149
Emperor penguin chicks climb on top of each other to get to the cozy center of a huddle where chicks keep each other warm.

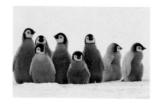

Emperor penguins, Antarctica, pp. 150–151 A gang of young emperor chicks trundles off to explore away from the colony.

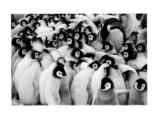

Emperor penguins, Antarctica, pp. 152–153 An adult emperor bends over to find its offspring in a crèche of chicks.

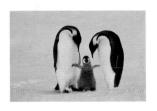

Emperor penguins, Antarctica, pp. 154–155 In a classic greeting ceremony, two parents bow heads over their chick.

Icescape, Antarctica, pp. 156–157 No penguin ventures into the interior of Antarctica, where lack of shelter and lack of food result in utter lack of life.

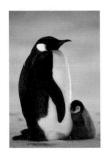

Emperor penguins, Antarctica, p. 190 A two-month-old chick nestles against a parent.

ACKNOWLEDGMENTS

My work with penguins extended over a period of a decade, and the success of each field trip depended on time and assistance from many organizations and individuals to whom I am indebted for their knowledge, generosity, and friendship. They gave me a rare opportunity to explore the lives of these wonderful birds. Thank you all.

Few people call penguin islands home. I had the pleasure to meet some exceptional individuals and families who do. Tony Chater graciously invited me onto his island and into his home. Sally and Jérôme Poncet shared their love and knowledge of South Georgia and made it a more hospitable place, all the more because of their sons, Dion, Leiv, and Diti. I owe a special tribute to them all.

Steve Pinfield, Anne Kershaw, and the staff at Adventure Network International provided superb logistics for an expedition supported by Hiroshi Moriya and his

colleagues at Tokyo Broadcasting System. The British Armed Forces at Grytviken came to my rescue when I suffered the dubious distinction of falling ill with malaria (contracted earlier in Madagascar) while camping on South Georgia. Bill Abbott and Ray Rodney at Wilderness Travel: Kim and Melanie Heacox; and Werner Zehnder. Peter Harrison and Shirley Metz. Mike and Sonja Messick, Carmen and Conrad Field, and John Splettstoesser at Zegrahm Expeditions all provided personal knowledge and excellent company on several ocean journeys. Scientists whose knowledge and passion for penguins greatly contributed to mine include John Croxall, Jerry Kooyman, Bernard Stonehouse, Frank Todd, and the late Peter Prince. Researchers at Bird Island, the British Antarctic Survey, and the Scott Polar Research Institute opened their doors and my eves to the intricacies of penguins.

The National Geographic Society generously supported fieldwork for much of my work with penguins. I thank friends and colleagues at the Society, especially editor Bill Allen and former editor Bill Garrett.

On the home front in the USA and Europe, and for help in the making of this book. I extend my sincere thanks and appreciation to: Bill Atkinson, Steve Kurtz, Sam Petersen, Galen and Barbara Rowell, Isabel Stirling; Larry Minden, Chris Carey, and Stacy Frank at Minden Pictures; the New Lab in San Francisco: Scott Andrews, Jerry Grossman, and Ron Taniwaki at Nikon; project editor Juliane Steinbrecher and Bernd Fechner, Klaus Kramp, Pedro Lisboa, Horst Neuzner, Karl-Heinz Petzler, Veronica Weller, and all the staff at Benedikt Taschen Verlag; Ausbert De Arce at Taschen USA; and the great staff at Frans Lanting Photography - Deborah Culmer, Abi Cotler, Sabrina Dalbesio, Mark Oatney, and Anya Thrash.

I owe a special word of thanks to

Jane Vessels for her treasured friendship
and professional judgment; to Kristen

Wurz for flawless production assistance;
to Jenny Barry, whose contributions go
far beyond the design she is credited for;
and to Benedikt and Angelika Taschen
for being such wonderful creative and
publishing partners.

To Chris, my love, always.

CONSERVATION

The fate of penguins depends on a few islands and ice shelves encircling Antarctica, and on their food supply in the Southern Ocean, one of the last great fisheries on earth that has not been overharvested by humans. As global warming brings changes in temperatures around the world, penguins will feel it directly. They are barometers. Their numbers are linked to the climatic stability, marine resources, and environmental health of an ecosystem claimed by many nations but protected by few.

Here are some organizations who look at this part of the planet not just as a place at the bottom of the world or at the bottom of an agenda, but as one of critical importance to us all, in every ocean and latitude.

The Antarctica Project

1630 Connecticut Avenue, N. W., 3rd

Floor

Washington, D. C. 20009 USA

Tel: (202) 234-2480

Web: www.asoc.org

Falklands Conservation

1 Princes Avenue

Finchley, London N3 2DA

UNITED KINGDOM

Fax: +44-181-343-0831

Web: www.falklandsconservation.com

BirdLife International

Wellbrook Court

Girton Road, Cambridge CB3 0NA

UNITED KINGDOM

Tel: +44-1223-277318

Web: www.birdlife.net

World Wildlife Fund

1250 24th Street, N. W.

Washington, D. C. 20037 USA

Tel: (202) 293-4800

Web: www.worldwildlife.org

WWF International

Avenue du Mont-Blanc

CH-1196 Gland, SWITZERLAND

Tel: +41-22-3649111

Web: www.panda.org

WNF-Netherlands

Postbus 7, 3700 AA Zeist

THE NETHERLANDS

Tel: +31-30-69-37-333

Web: www.wnf.nl

WWF-Germany

Postfach 190 440

60326 Frankfurt, GERMANY

Tel: +49-69-791-44-0

Web: www.wwf.de

Terra Editions produces and distributes

books, posters, and fine prints of Frans

Lanting's work.

For information, please contact:

Terra Editions, 1985 Smith Grade,

Santa Cruz, CA 95060 USA

Fax: (831) 423-8324

E-mail: info@lanting.com

Web: www.lanting.com

Terra Editions donates a portion of all

proceeds to conservation programs.

Page 190: Emperor penguin and chick, Antarctica

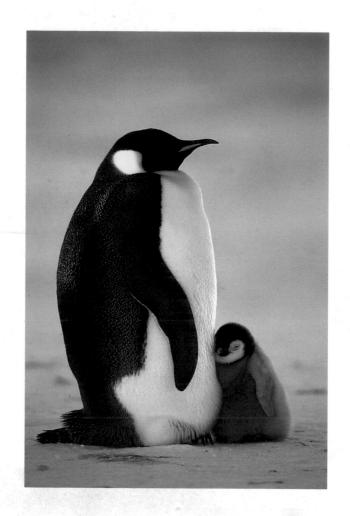